The Bunkhouse Boys

The
BUNKHOUSE BOYS
from the Lazy Daisy Ranch

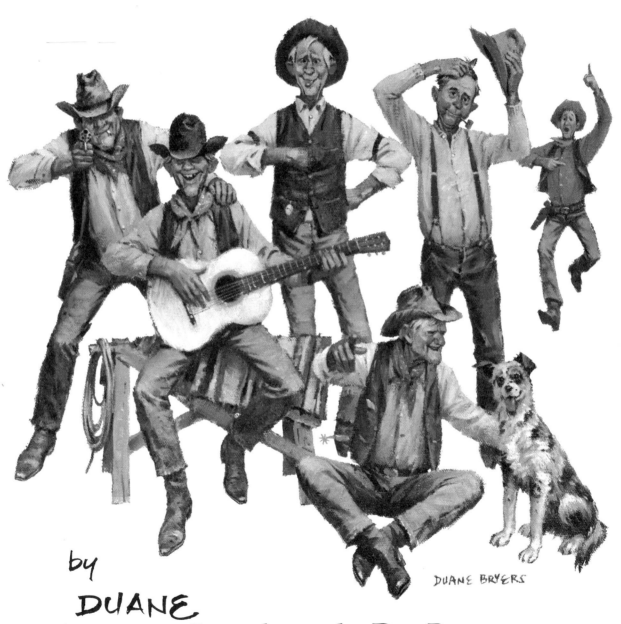

by
DUANE
BRYERS with text by Dee Ray

 NORTHLAND PRESS

To Walter, the Boston wrangler

THE BUNKHOUSE BOYS *are make-believe cowboys who live in an imaginary bunkhouse on a non-existent ranch. Any similarity to real persons is coincidental. What they do and what they say is fiction, and any similarity to true facts is accidental. From cover to cover, it is a western fantasy. But if* THE BUNKHOUSE BOYS *seem as real to the reader as they are to the artist and author, then the fun of creating them has been greatly enhanced.*

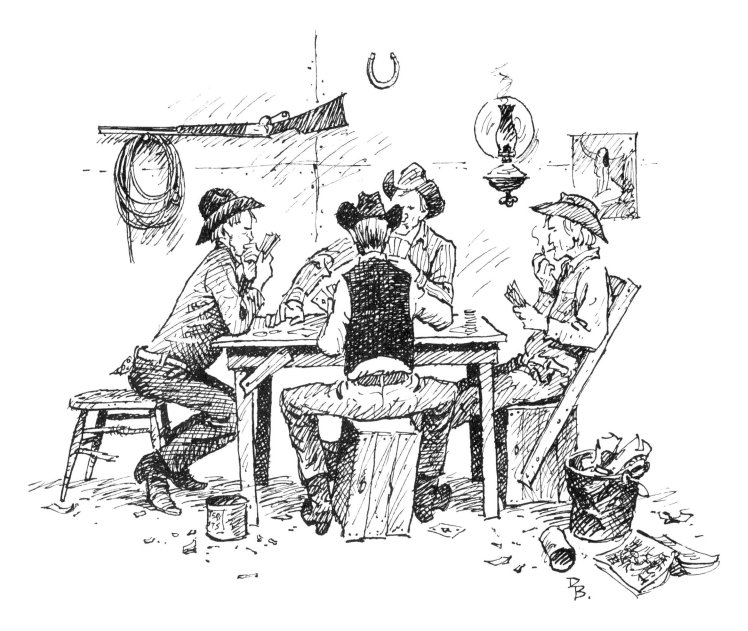

A Day in the Bunkhouse

As told by "Mule" Scruggs

I'M MULE SCRUGGS, and I've lived my whole life mostly under the sky. Working or sleeping, it's seldom there's a roof to blot out the sun or the stars. Until day before yesterday. We had taken on a bunch of new hands to help with spring roundup, and one was a genuine sweetheart, duded up like he'd just stepped out of a Sears Roebuck catalog. Me and Oats, he's my friend, figured we'd have some fun. We took Fancy Pants over to the corral with the fellers straggling along, and I asked this Stetson lad if he thought he could saddle bust that young horse in yonder corner. He said, "Shore, nuthin' to it."
And there wasn't. In fifteen minutes he made our top broncbuster

1

look like Ned in the First Reader. What burnt me up was the dumb whick didn't even lose his hat.

The boys on the fence were wearing out their elbows jostling each other and laughing, and one smart aleck wanted to know how come my ears was so red. Even Oats was grinning. Empty-headed, I heard myself telling Oats to haze Big Red into the corral — I'd show 'em some real riding. Oats couldn't grin with his jaw hanging open, but he ain't one to interfere in another man's folly. He just asked where should he bury me.

Oats' misgivings didn't stay him from helping me bridle the old outlaw. Soon as I eased into the saddle, I knew I was straddling a short-fused keg of dynamite that would explode the second it felt my weight on its back. Sure enough, he went straight up, pawing the air, and let out a spine-tingling squall of pure meanness before he come whistling down. From then on it was goodnight Charlie as he bucked and humped his back into stiff-legged jolts that about stove my rear end into my rib cage. After ten minutes of listening to my teeth rattle inside my head, I was figuring on maybe parting company with him and had my feet almost free of the stirrups when he stalled, sulking and blowing hard, the sweat pouring down his withers.

I took a drag on the cigarette that was glued to my lip, relaxing somewhat and wondering what the hell I had for brains. Straight out of nowhere that tricky bastard flopped himself sideways and brought twelve hundred pounds of horsemeat crunching down on my leg. He let me sweat a minute before he scrambled up and careened off towards the gate. Through the dust I saw Oats bending over me and heard him ask, "Mule, ain't yuh never gonna learn how to leave a saddle?"

My right leg felt like a stocking full of mush — until I tried to stand on it. Man, did that hurt! A couple of the boys packed me into the bunkhouse and dropped me onto a cot, busting themselves to be polite. Not Oats. He called me names only a friend can get away with as he cut off my boot. Then he took the Model T into town to fetch the Doc. They showed about sundown. Doc slathered horse liniment on my swollen ankle, wrapped a torn hunk of old bedsheet around it with strips of shingles for splints, and told me to stay put for several days. The notion of being walled up in this bunkhouse jolted me worse than Big Red did.

God, was it a rough night! When a man gets used to sleeping in the open, a roomful of snoring cowhands and stale air is rankling. Besides, them ligaments were giving me hell as I lay there pop-eyed, staring at the ceiling. I have slept in the bunkhouse before, but in the next twenty-four hours I was going to notice more things about it than I ever had. Sometime during the night Oats got up and lit the old lantern hanging by the door and went outside. Through the window I could see the lantern light and the long criss-cross shadows of his legs as he walked towards the stable to check on a mare due to foal. Seemed like morning was fifty miles down the road.

At five o'clock the bunkhouse was still dark as a root cellar, and I was still awake. Our wrangler was already out in the corral getting the horses ready for the day's ride, and I could hear Cookie chopping wood out back of the cook shack. The boys sleep as hard as they work, but the sound of Cookie's axe can split a feller's dreams quicker than any alarm clock. We don't have one, anyways. When you've spent years rolling out before sun-up to ride miles of grassland, greasewood and roughs, a built-in clock and compass comes natural. It was comical watching them squint-eyes fight their blankets as they come to, stretching and scratching. I was scratching some, myself. Nobody can tell me it ain't better sleeping outdoors. I think it was Oats struck a match to the coal-oil lamp, but the chimney was so black it didn't help

much. In the dim light the fellers were stumbling into each other as they splashed cold water on their faces, rooted in their war bags for a shirt with buttons, or tackled their Levis. I took note for the first time what a sad-looking outfit a baggy suit of long-handled underwear is. "Damn, you guys are ugly," I said. Nobody paid any mind.

The sun was no more than a handspan above the buttes when Cookie commenced to beat hell out of a washtub with his soup ladle, loud enough to turn a stampede. You don't have to be good at ciphering messages to get the idea breakfast is ready, but it takes some training to know Cookie don't tolerate no latecomers. So the boys didn't lose time getting out the door, some still tucking in their shirttails. For all their squawking about Cookie's flapjacks being cut out of saddle leather, I never knew one of them heroes to turn down a chow call.

The cook shack ain't the fanciest place to put your feet under a table, with its rough boards and wobbly benches and clatter of forks against tin plates. The big iron cookstove is loaded down with Cookie's five-gallon pots and heavy skillets and looks as if it'll go through the floor any minute. And he ain't the neatest cook. Flour is strewed all over him and his work table like they'd been in a blizzard. But the cook shack is mighty inviting when Cookie has kept a pot of coffee steaming on a freezing night because he knew you'd be late coming in.

Oats was still trying to pull his boots on. He sure likes 'em tight. I told him if he'd own up to having big feet and buy the right size, he'd save himself a helluva lot of trouble. Then he says if I'm so dang smart, how come he's the one going to breakfast. I allowed he had a point there and asked if he'd do me a favor and fetch me a cup of coffee. He said he would but didn't consider it no favor. Oats swears Cookie's coffee is a sure cure for snake-bite, providing the snake drinks it first.

After the boys had eaten their flapjacks, and had taken their hats, ropes and other trappings off the wall pegs and cleared out, the bunkhouse

4

was quiet as a night horse. Only sound was the droning of a few flies and every once in awhile our old hound would hoist his head off his paws to snap at one. He's a short-haired wonder, name of Mose. Mose, I thought, you're a good dog but a lousy substitute for them cows I'm supposed to be gathering.

Sunlight was streaming through the dirty windows best it could. Them windows would bother some folks. Won't stay open in summer without a prop and don't do any good closed in the winter, what with the wind whistling through the busted, rag-stuffed panes. The shades are in tatters and stuck permanent. The bunkhouse sure shows up different when daylight is laying bare the looks of the room. I couldn't recollect ever having seen it real good before. The boys' bunks, strung out end-to-end with their moth-eaten blankets rolled up neat at the foot, look like a pack string of swaybacked cayuses. Under each bunk is a war bag or a beat-up suitcase or a canned tomato carton — anything to store personal belongings in. Not that a cowboy has much except his clothes and the tools of his trade. Me, I own a razor, my pa's pocket watch and a dog-earred deck of cards. There's scarce space for the rest of the furnishings — a rickety washstand gummed over with soap drippings, an old kitchen table, three partially whole chairs, and an orange crate. Plus the stuff scattered around — a stack of wild west stories by that Zane Grey feller, a guitar, some rope being spliced, and a mess of clutter on the window sills. I forget what all.

Mose got up and ambled over to the boxwood stove where he lay down again. It's his favorite spot in winter when the stove is red hot and the boys are frying their frontsides and freezing their backsides. That's when the place looks like a damn Chinese laundry, with wet boots drying under the stove, and wet socks, neckerchiefs and underwear hung up over the stove, steaming or scorching. Back of the stovepipe, the plasterboard wall is smoked black. But that ain't the only decorating

that's been done to the wall. In one place it's covered with old newspapers to hide bullet holes made a long time ago by a whoopee-eyed puncher in the habit of shooting bedbugs and other wildlife. And every cowboy who's stowed his boots under these bunks has pasted up and left behind a fly-specked calendar or faded photograph. Oats' collection of naked fillies and pure-bred Herefords is a sight more colorful. Square over my bunk the ceiling is stained from the leaky roof and sagging like a hog in a wagonsheet. I was studying the stains and getting drowsy when Cookie came in carrying a bowl of soup and muttering "needn't think I made it special" and "ain't got no time to play nurse."

Even so, he found time to sit a spell and tell me what was going on outside. For an old codger who spends most of his time up to his elbows in biscuit dough, he sure knows who's where doing what. He said Oats was all over the place like a rash, readying the wagons, fixing loose-spoked wheels, and trying to put the engine I had been working on back into the pickup, and wanted to know if I didn't think Oats was spreading himself a little thin. I said I didn't know about that, but I knew damn well if he didn't quit messing around the machinery, the whole flapping roundup would come to a screeching halt when things started falling apart out in the boondocks. Oats is good at pulling cows out of mudholes, shoeing horses, feeding dogies, or whatever comes natural, but give him a wrench and a mechanical chore and you got yourself a handful of spare parts that ain't nobody going to figure out where they belong.

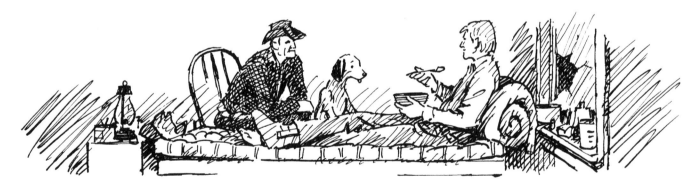

I reminded Cookie of the last time Oats had his noggin under the hood of a jalopy. He got it to run, that's for sure, but only in one direction — backwards. Tore down half the corral and knocked over the biffy before he thought to stomp on the brake. It didn't perturb him none. "Boys," he said, "I got 'er fixed fer yuh. Jes be a mite keerful gettin' 'er started an' keep your eyes on 'er tail end."

6

Just after Cookie took off, Oats come in, covered head to foot with axle grease, and said he'd done all he could for me. Said if he didn't get them horses shod "wasn't nobody going to round up nuthin'." I told him I was grateful, but I didn't say for what.

As the afternoon took hold, it turned hot. Too hot for this time of year. It ain't rained for a month of Sundays, and the range is dry as a bone. Waterholes are dry, wagon wheels are dry, the old windmill creaks dry. The only thing not dry was my shirt. I was mopping my face and trying to ease my foot when I saw a whirlwind twist up out of the corral and head straight for the bunkhouse. Mose had changed location again and was spanning the doorway. It took him a flat second to gather his legs under him and scoot for cover. He can move quick if he's of a mind to. The dust spun through the doorway and halfway across the room before it died down. Too bad it didn't blow on through and clean out the place. The floor was bootheel deep in cigarette butts, apple cores, and empty bean cans. When we've kicked the clutter around 'til it starts festering, someone finally takes a shovel to it. A cowhand is breathing dust most of his waking hours anyways, whether it's from the drag end of a herd of cattle or a bawling calf on the other end of his rope.

I found a soft spot in the hay-filled mattress Oats calls "Montana feathers," rolled me a cigarette, and wondered what the hell else happens in the bunkhouse when we ain't here. I remembered one particular event. It was the time a passel of skunks moved in. Now a bunkhouse draws a right smart number of visitors, mostly pack rats, but these new arrivals had set up permanent quarters under the floorboards, and while we're accustomed to a tolerable amount of disagreeable odors, the prospect of sharing our shanty with a mess of polecats was a shade much. So we pulled straws to settle who would perform eviction proceedings, and Oats won. He's always complaining that he "don't never win nuthin'." Win or lose, in no time he had a couple of floorboards ripped up and them skunks hightailing it out of there — and so was Oats as he headed for the creek. Two hours and four bars of soap later he was still soaking out scent and splinters.

To this day them floorboards are missing. And what's left of the floor is so warped it looks as if it's fixing to leave. If it does, I reckon the walls will go with it. Ain't one panel not pulled loose from the rusty nails.

The boys rode in long about sundown, and I could hear them joshing and carrying on down by the corral. It's a good feeling, after all the dust and sweat, to point your horse towards a speck of ranch windmill and ride into an orange-colored sky. Soon as they took care of their horses, they came in to wash for supper. Oats was in the stable tending Churnhead on account of she was ailing. That's Oats' private mount, and he's touchy about her — gets mad clear through when the boys call her "buzzard bait." Mares ain't worth two cents in the cow business, temperamental and always causing trouble, but Oats would rather lose a season's wages than part with that whey-bellied old bunch quitter. Seems Churnhead had wandered off while Oats was shoeing the horses and found herself a patch of loco weed.

The fellers finished slicking down their hair, and two of them loaned me their shoulders while I crow-hopped on one leg to the cook shack. By the time we got there the boys were halfway through their first helping, and the biscuits were disappearing faster than Cookie could pull them out of the oven. Some of the boys slid over and without missing a bite helped me to sit with my leg stretched out on the bench. Instead of griping about the grub, they were jawing about a dance at

the Johnson ranch next Saturday night, big-talking how they would sweep the ladies off their feet. I nearly swallowed a spud whole at the notion of Birdie Johnson getting swept off her feet. Birdie weighs close to two hundred pounds, solid muscle. Listening to these Romeos, you wouldn't know they were the same fellers if you could see them perched on the edge of Miz Johnson's horsehair sofa, skittery as colts and eyeballing the nearest door, 'til the gals sweet-talked them into dancing. Or at least what the boys *called* dancing.

As we dumped our plates in Cookie's dishwater, he acted half sore. I reckon he was peeved at not having had a chance to yell back at our complaints about his cooking.

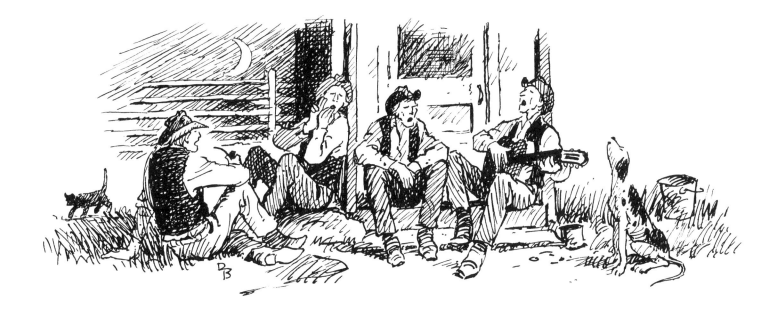

It was turning dark and cooling off some, but still too warm to go indoors so we sat on the stoop. Oats drifted up saying Churnhead was feeling better — leastways she wasn't crosseyed no more. We figured that was good enough reason to celebrate. That, and the party coming up. So we rounded up a guitar, Oats' old ukelele and a Jew's harp and had at it, each one playing according to his own version or inventing his own words. What was lacking in harmony was made up for in feeling. Jake, the foreman, stopped by — said he thought he heard a pack of coyotes circling in on a maverick and come to investigate. Even Cookie come running out of his shack yelling that his sourdough couldn't rise on account of all the racket, and why in hell weren't we playing poker like we generally do. That seemed a good idea. We'd enjoyed ourselves as long as we could stand it, anyways.

The night air had chilled the bunkhouse, and it felt good to be back in the cot with the covers drawed up. Oats and three of the boys broke out the cards for a round of stud and Mose, tuckered out from doing nothing, meandered over to their table, made a few gyrations, and nestled near their feet. Now and then one of them would rub his boot against him or reach down and scratch his ears. The two other fellers were sitting on the edges of their bunks, one mending his saddle and one finishing his rope-splicing. In the lamplight, the bunkhouse looked snug as a sage hen's nest. The yellow slickers hanging by the window formed a kind of curtain that seemed to move as the light cast wavery shadows on the wall. I reckoned it was high time I bought me a new slicker. On a rainy night my old one gets so sticky I'm damn near glued to my saddle. Should of been wearing it when I tried to ride Big Red.

Oats left the game and took the lantern out to the two-holer. He likes to sit out there and mull over the catalog. I remembered one night when Oats had been gone for nigh onto an hour, and the boys got more than somewhat testy on account of Cookie's bean supper. They finally traipsed out to expedite matters and found him scribbling words on the wall. I don't rightly think they appreciated Oats' choice of time and place to satisfy his craving to write a poem but you can't discount me none for getting a kick out of what he wrote:

"My legs are long and bowed in the middle
 When they git to the bottom
 They flatten out a liddle
 And them's my feet."

Oats is real good at making up words.

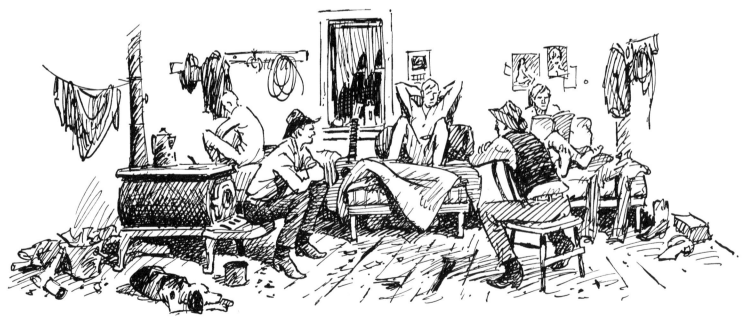

The boys were slapping their cards on the wore-out oilcloth, saying nothing or too much, depending on what they'd been dealt. One of them had "found" a near-empty bottle in his war bag, and they were sharing it, making it last. They ain't jacklegs at downing the hard stuff but lay off it at the ranch — except for a little touch once in a blue moon. On payday some of them can cut loose from their forty-a-month quick as it takes to push open a swinging door. Every so often a ranch hand needs some bolstering when his only family is a bunch of broncs like himself. Kinfolk is something a cowboy gets a letter from maybe twice a year, telling him who all's died or asking to borrow money. I got to thinking what it'd be like, having a missus and some younguns and living in a little gray stucco house that had a garden maybe and a couple of horses out back. But not for long. "Mule," I says to myself, "Big Red must have jarred something loose in your head for sure. You ain't never going to see the inside of nothing but a bunkhouse." One thing about bunkhouses, though, ain't no two of them alike. Some are made of logs, other board-and-batten, some adobe. And some are just holes in the ground now. The Lazy Daisy's old sod line camp over on Gulch Creek where we store feed has walls two feet thick that keep it warm in winter and cool as spring water in the summer. When we're out riding fence or checking cattle and grass, we stop there to water our horses and maybe talk about the old days when there were land grants and longhorns, and the latchstring was out to whoever rode by. Oats swears the old sodhouse is haunted because Churnhead won't go near it.

I dozed off but woke when the boys finished their game, turning in early for the hard day ahead. There's might near as much commotion getting to bed as there is getting up. Oats was cussing like a bullwhacker, trying to figure the long ends of his blanket, and two others were arguing whose turn it was to fetch in the water. They finally bedded down, forgetting to blow out the lamp, so there was a big hassle about whose fault it was 'til the guy nearest jumped up grumbling "Fer crissakes."

11

It was peaceful and quiet for all of two minutes. Then out of the darkness somebody started telling about a horse he once had, and that was enough to set them all to spieling their favorite bronc story. When Oats claimed Churnhead was the "fastes' horse livin' onct she got goin'," I decided that one more night in this two-by-four chicken coop would put me in prime shape for the loony bin. Besides, there was a full moon showing, and I reckoned with a good night's sleep I could drag my ass under that pickup and work on the engine come morning.

Oats understood my hankering and helped get me and my bedroll moved clear down near the corral. In the goddam moonlight, under the lonely stars, I slept.

SPEAKIN' OF BUNKHOUSES, we got a picture of ours. One of them
artist fellers was out here not long ago, hangin' from the top of
our windmill while he drew it. Sure beats me why anybody would want
to paint a picture of an ol' bunkhouse 'stead of a pretty sunset but
anyways, here it is . . .

13

The Lazy Daisy Bunkhouse

ISOLATED FROM THE MAIN RANCHHOUSE and located in the midst
of corrals, stables, tackroom and sheds, the bunkhouse is a small world
in its own universe. A recent rain has freshened the sparse grass
and washed clean the usually dusty surfaces, its cloud-shadows still
passing across the corral where one of the ranch hands is taking some
of the sass out of his overly spirited mount. The boys are whiling
away a leisurely Sunday morning, two of them getting an early
start on some routine range assignment. Another is optimistically
sprucing up for a day in town if he can tinker the Model T into
starting — after he fixes the flat. Sunday is a good day to catch up
on chores — or maybe just do nothing. The bunkhouse sets hunched
like a brooding hen, its ramshackle walls buried in a nest of accumu-
lated odds 'n' ends. Accepted without question by its tenants, it
keeps their identities forever secret as, season after season, they linger
a while on their way from nowhere to nowhere. Without pretense,
dilapidated from years of neglect and the vagaries of wind and
weather, ignoring the passing of time, it staunchly provides what
comfort and shelter it can — from its sagging doorstep to its
shingle-shy roof.

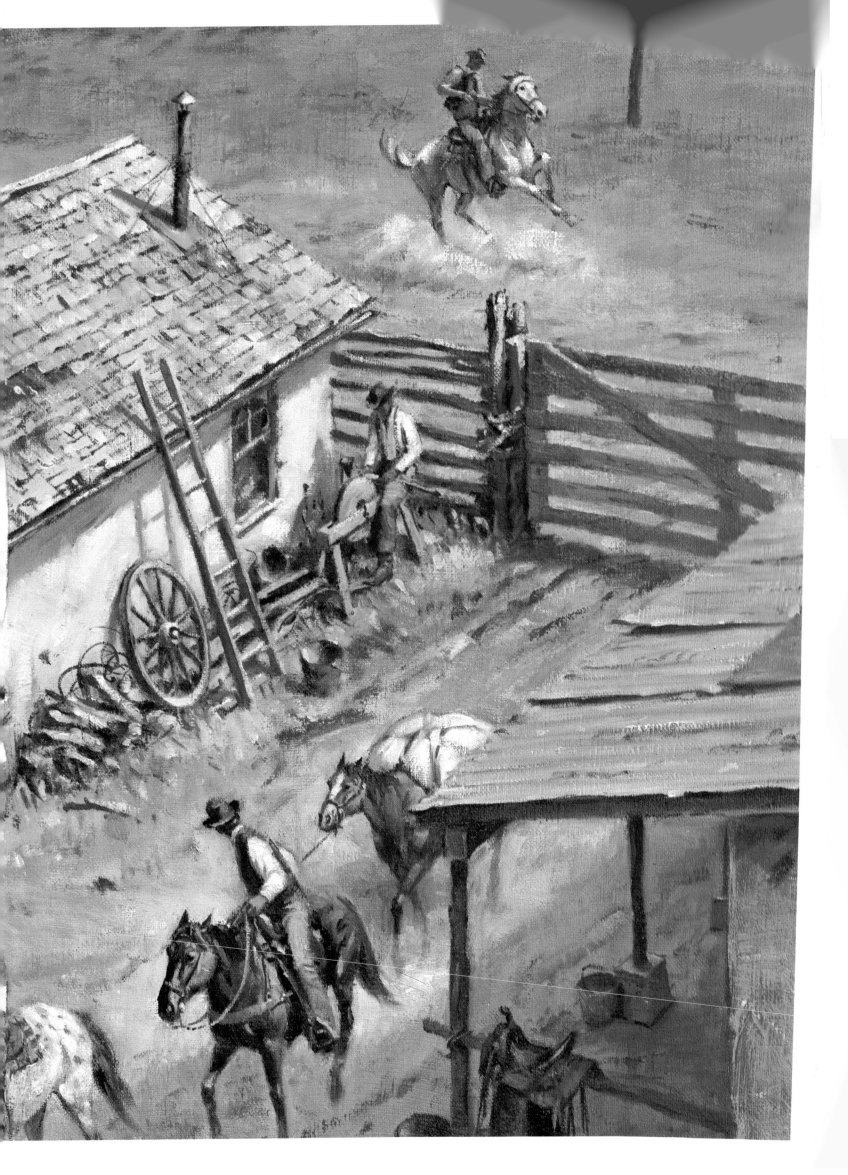

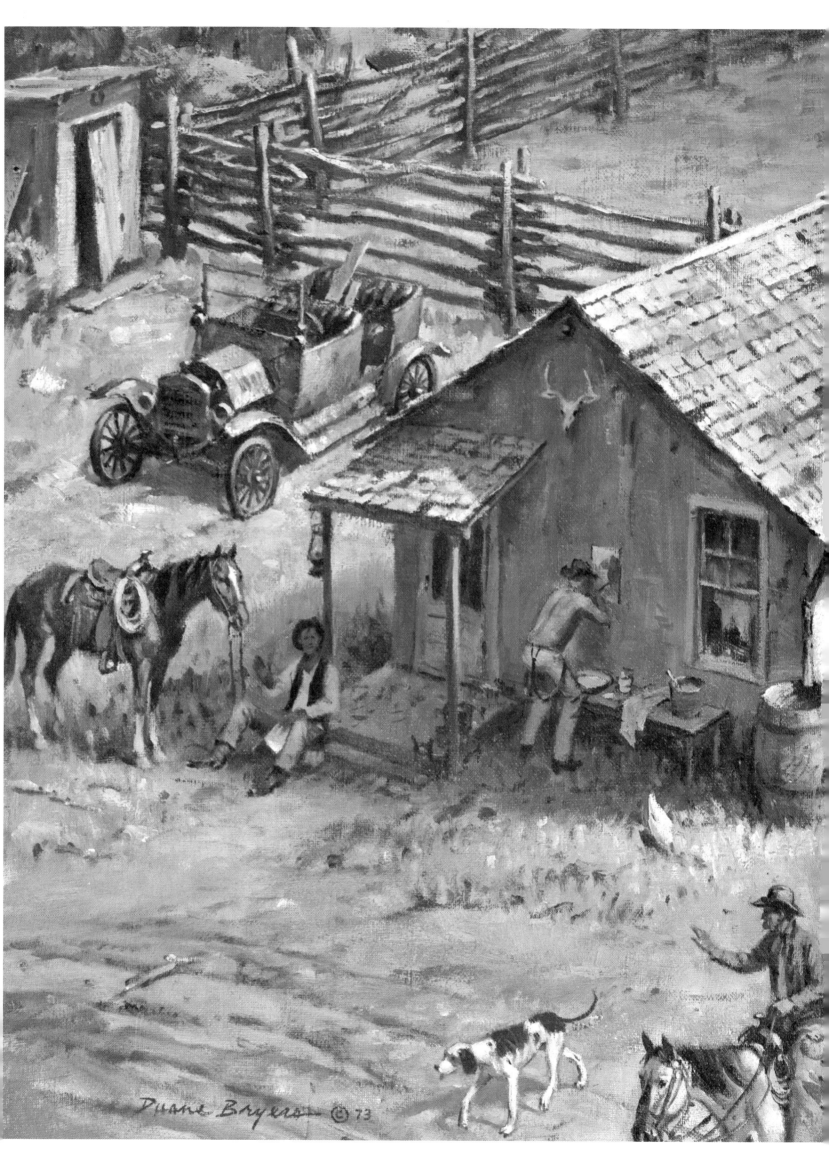
Duane Bryers © 73

Welcome to the Lazy Daisy Ranch

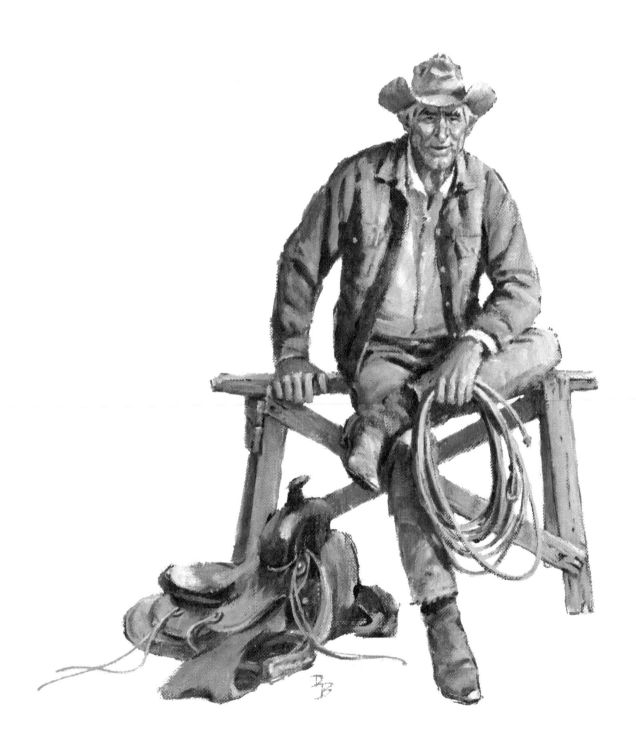

HOWDY. I'M JAKE MOSS, foreman for the Lazy Daisy. I'd like to tell you about some of the boys who have worked for my outfit. Some of 'em I knew personal — those who were here in the old days I just heard tell of.

21

"Bubbles" Larson

Bubbles was a lumberjack in Minnesota before he signed on with the Lazy Daisy. Real gentle, Bubbles was — did a lot of thinking. That's why he gave up logging. He couldn't meditate with those big timbers coming down. Trail herding and nighthawking suited him better. The only beef Bubbles had was putting up with little guys trying to prove something. Like the time he was in Lucky's Saloon and Shorty Jackson kept interrupting his thoughts all evening, wanting to know if Bubbles was scared to step outside. It took the bartender and three other fellers to get Shorty off the chandelier.

DUANE
BRYERS © 73

"Pops" Mulligan

Thirty years of cooking meals in sub-zero weather, sandstorms and
desert heat from 'fore sunup to sundown had put a keen edge on Pops'
temper. If his chow call was "Roll out, you sonsa—" or "Grab it
and gnaw," the boys could figure his disposition was fair and sunny.
But if they were woke up by the unholy racket of his Dutch oven lids
banging together, they didn't trifle with his feelings. Rocks in your
beans was mighty disagreeable, especially when Pops was the only
"dentist" to hand. It didn't take a greenhorn long to learn the laws
of territorial rights if he came barging into Pops' cookhouse uninvited.

24

DUANE
BRYERS ©73

"Bugs" Benny

Peace and quiet was downright exasperatin' to Bugs. His Saturday nights in town were pure hell for the barkeepers. At three in the morning and full of hootch, that lop-eyed, caterwauling ol' coot would turn the bunkhouse into a roarin' shambles. When shooting bedbugs off the wall got boring, he'd commence telling of his run-ins with road agents, desperadoes and Apaches. Every time his jaw moved, he'd pull the trigger. The boys were too busy dodgin' lead to notice whether Bugs or the Apaches were winning. Nobody ever did hear how his stories ended. Bugs would pass out with a bullet in midair and his mouth wide open.

26

"Moose" Johnson

"You shoulda seen Nogales thirty years ago," Moose was always saying. That's where he threw in with Pepe. A knife-slinging *hombre* was pinning Pepe's ears to the wall over five aces showing. Those border towns were Moose's stomping grounds 'til he took to hankering for his own spread, and the two of them came to work for the Lazy Daisy. He and Pepe started building a herd the hard way with one bull and two cows. They kept up a running argument about who would do the cooking when they got their ranch — Moose claiming Pepe's beans would burn a hole in the hull of a battleship and Pepe insisting Moose's biscuits would sure as hell sink it.

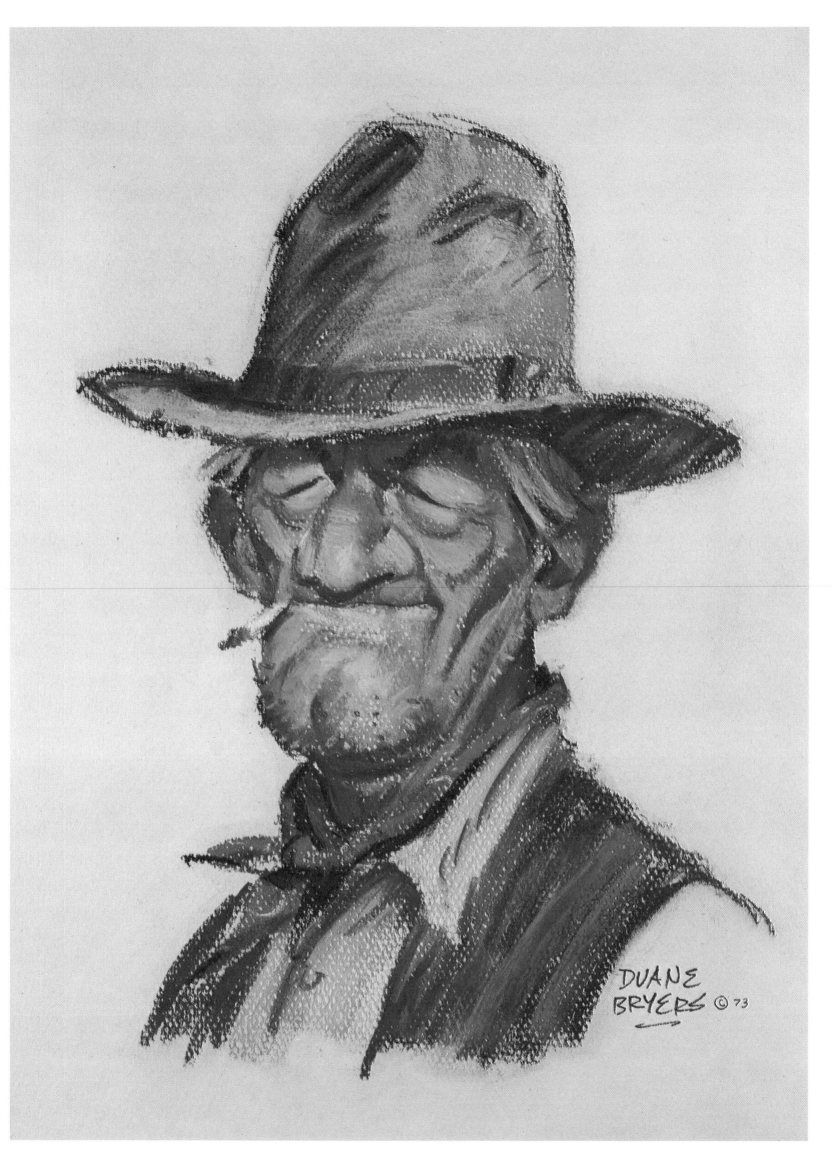

"Pepe" Gonzales

It was plumb comical the way Pepe would imitate Moose — from picking his teeth to rolling his own. He dang near ruptured himself trying to walk like Moose, being knock-kneed 'stead of bowlegged. Pepe's gambling habits was the only other subject they'd argue about. Every payday it was, "How about a leetle game of carts?" Those words got Pepe into more trouble than he was equipped to deal with, but he never gave up. For a little feller, he sure thought big. He'd double the ante every time — then holler for Moose. Moose kept telling him if he didn't stay out of those poker games, he'd send him back to Nogales on a burro.

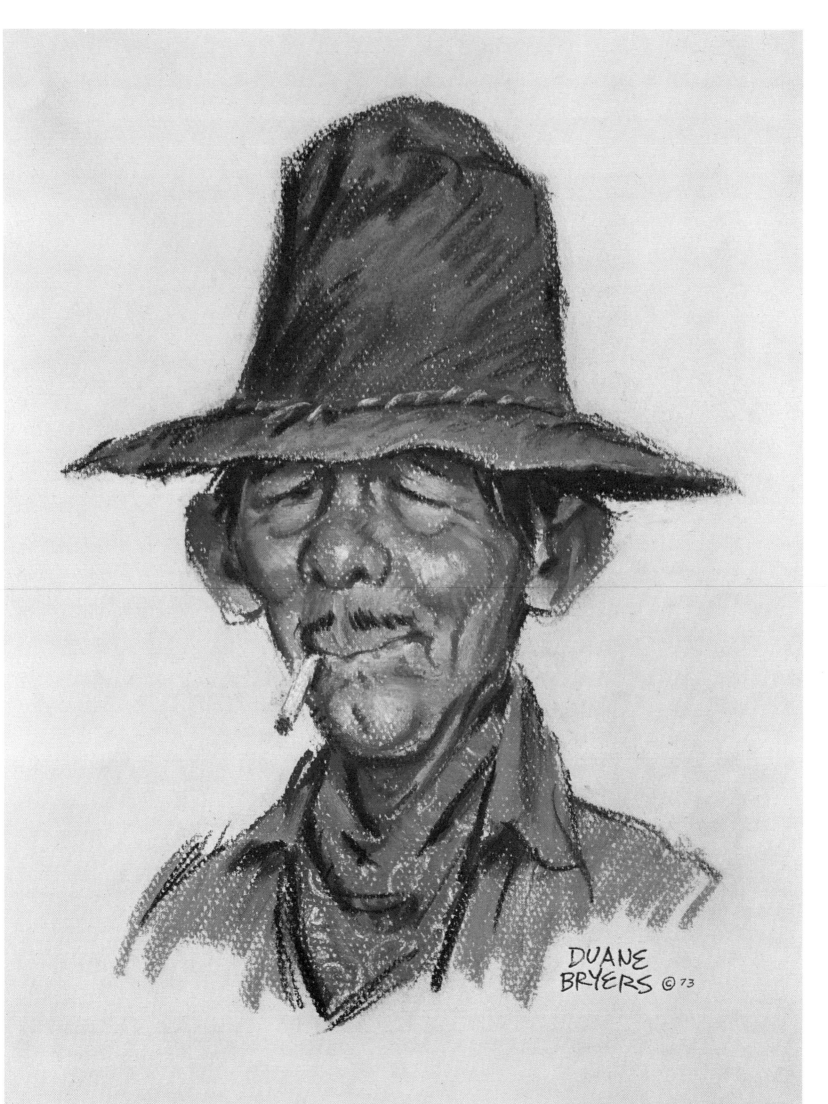

DUANE
BRYERS © 73

Ramon Schwarts

It took a long time for the boys to forget Ramon. According to him, if there was a woman living who wouldn't keel over in a dead faint if he so much as looked at her, his name wasn't Ramon Schwarts. And if he was to wink, there's no telling what might happen. There were two places the foreman could find Ramon, trying on his hat in front of the shaving miror or looking at himself in the water trough. The foreman was hard put to decide whether to push him in or fire him, so he done both. The cold water must have cleared Ramon's head because he just remembered there was a little showgal in Kansas City beggin' him to come get her.

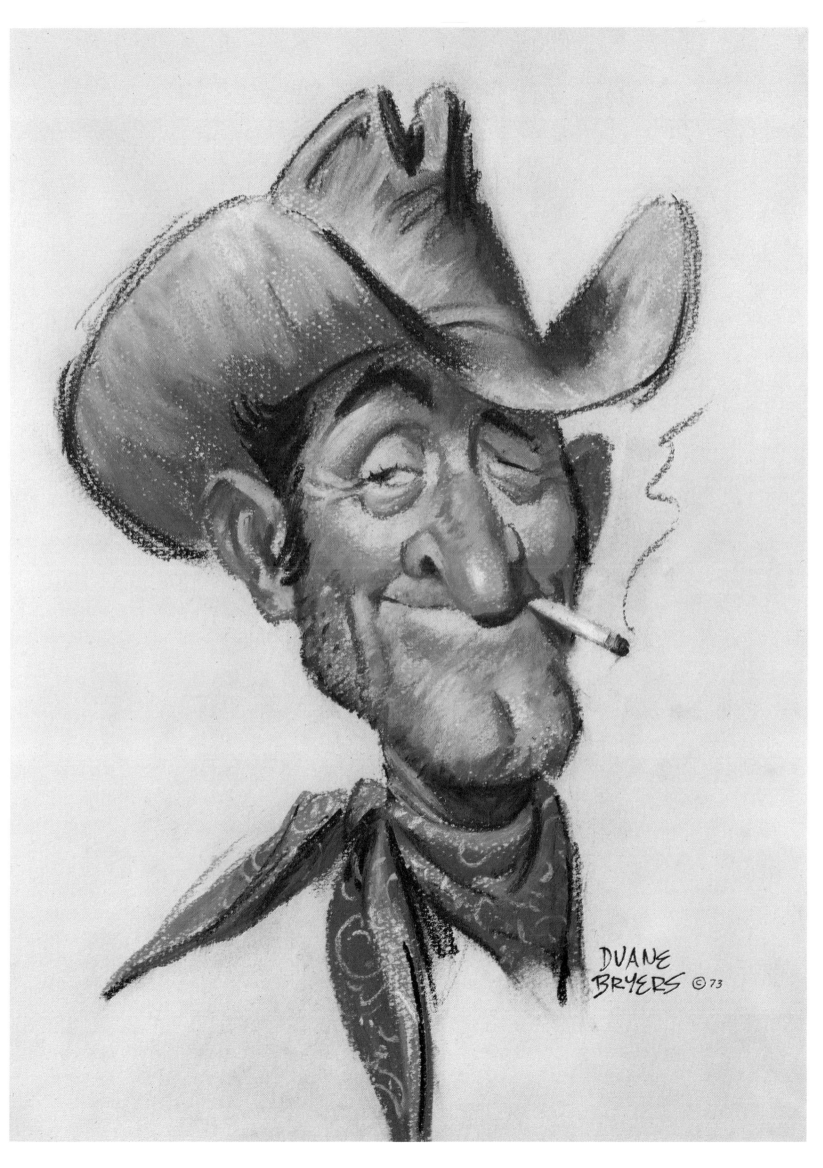

"Knuckles" Kowolski

He came out west from Peoria to homestead a quarter-section with
nothing but high hopes and a stringy little wife. After working his
fingers plumb down to the kunckles, his well went dry about the
same time his cow did, which was just before his wife ran off with
Ramon Schwarts. With the coyotes gettin' fat on what was left of his
chickens and his sod roof leaking like a sieve, he didn't need no pencil
to figure where he was at. He reckoned punchin' cows was a sight
easier than grabbing hold of that plow. Whenever the boys got to
bellyaching about working twenty-six hours a day, Knuckles would
ask 'em if "them hours was in the mornin' or the afternoon."

34

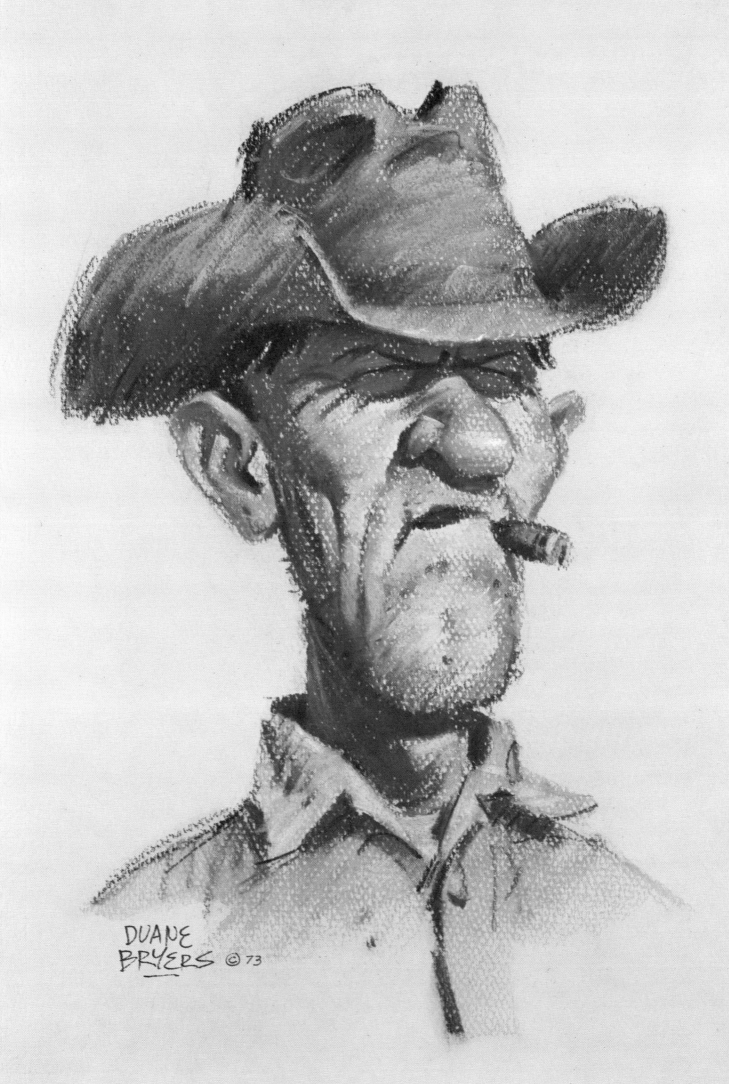

DUANE
BRYERS © 73

"Doc" Axelrod

When Doc wasn't mining lead out of some cranky gunslinger or if he
was sober enough to hitch up Lightning, his services were available day
or night. Doc's remedies were the same whether his patient had two
legs or four. If his "Miraculous 3-Hour Cure-All" failed, he'd try
hot applications of goose grease and turpentine. Sometimes he'd
forget what was ailin' his patient. It was a rough go for one old
broncbuster with a busted leg when Doc gave him a "fast-acting"
tonic. The boys used to say having "Greasy" Axlerod for a doctor, a
feller could die and never know the difference.

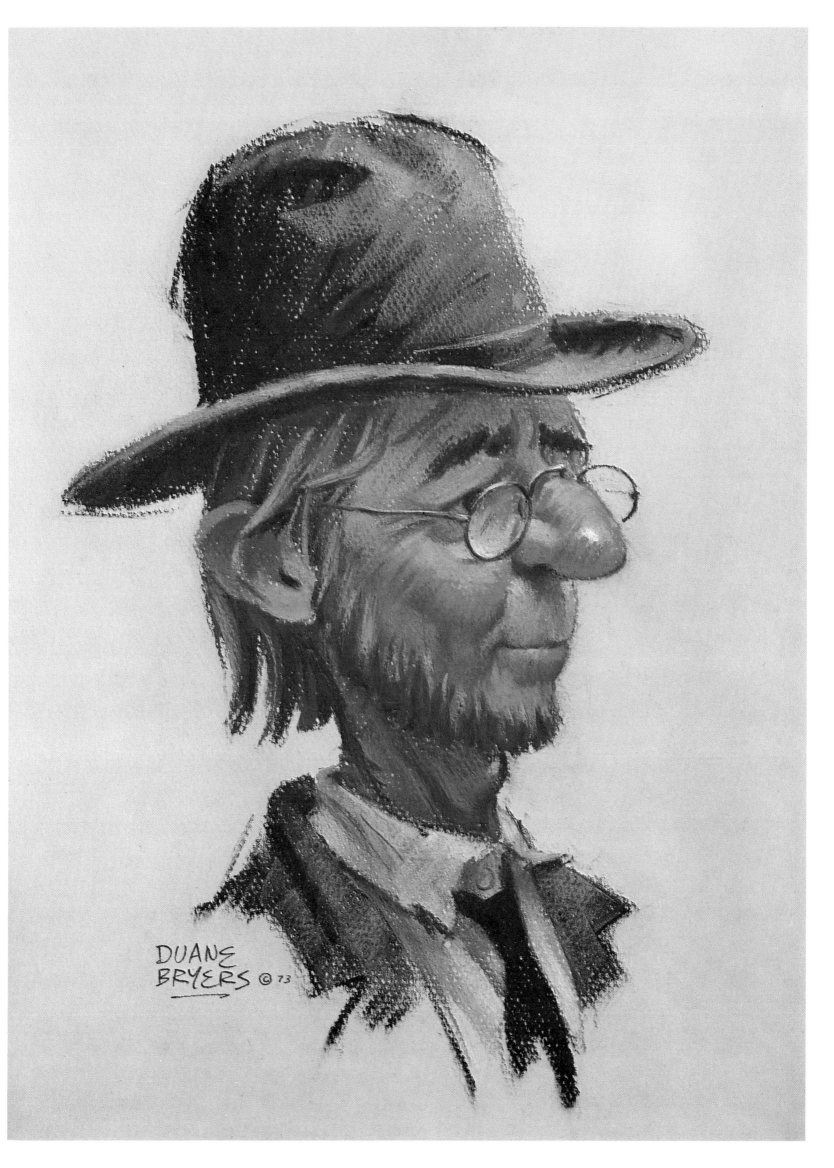

DUANE
BRYERS © 73

"Taters" Daily

One way a rancher could go broke was to hire Taters — providing the rancher had a good cook. If the grub was lackin' in quality or quantity, Taters was notorious for dragging up and heading for another outfit. What that sawed-off little runt couldn't pack inside, he'd pack outside. Once his hind pockets were so full of biscuits he had to ride standin' up in the stirrups. He was a real genius with them branding irons, though. One of the boys said it was because he liked the smell of burnt meat. The only time Taters didn't get to the chow line first was when he stumbled over somebody's foot which just "happened" to be in the way. Even so, he came in second.

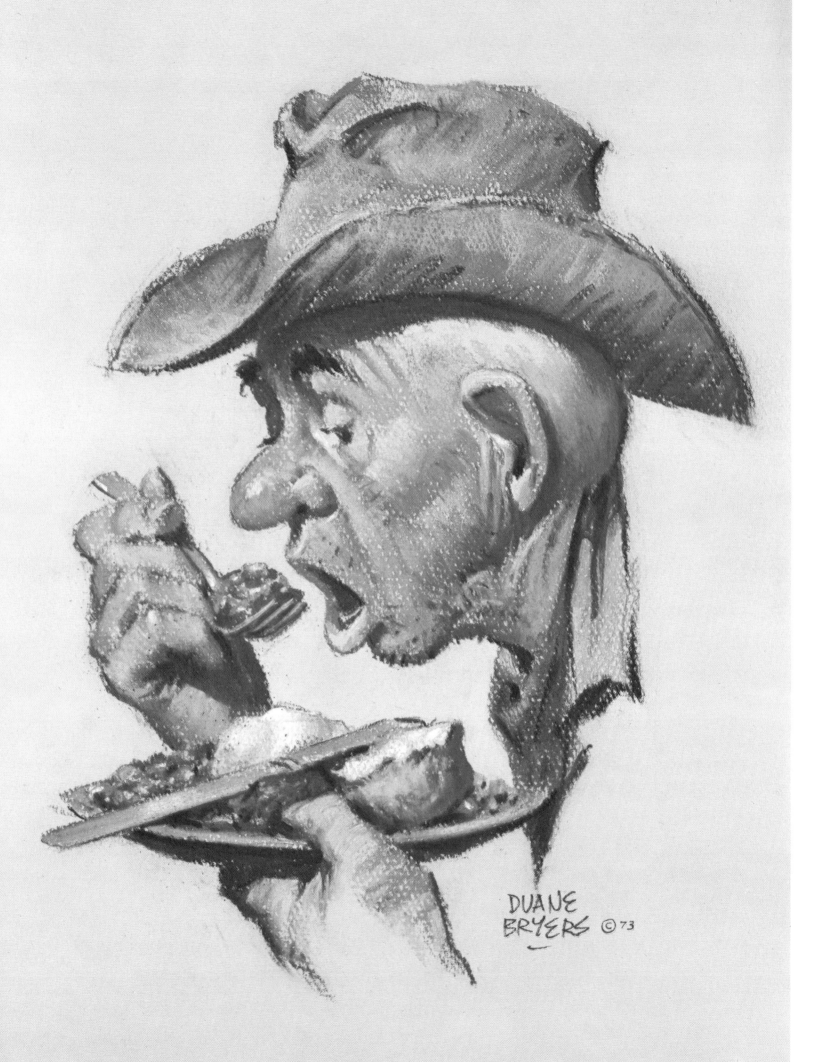

"Spade" Dooley

Somebody in Dodge City once told him he looked like Wyatt Earp, and he played it to the hilt. He rode into town one jump ahead of the sheriff, right after the boys drew their pay, and might near cleaned out every one of 'em — except Pops. Pops knew better than to get in a game with a dealer what dealt the cards from that close to his chest. Spade hightailed it out of town the next morning but it wasn't his hammerhead Appaloosa that was packin' him. The boys had seen fit to do a little swapping, and Spade sure was a sight, straddling that mule while the fellers helped him along with their six-shooters.

40

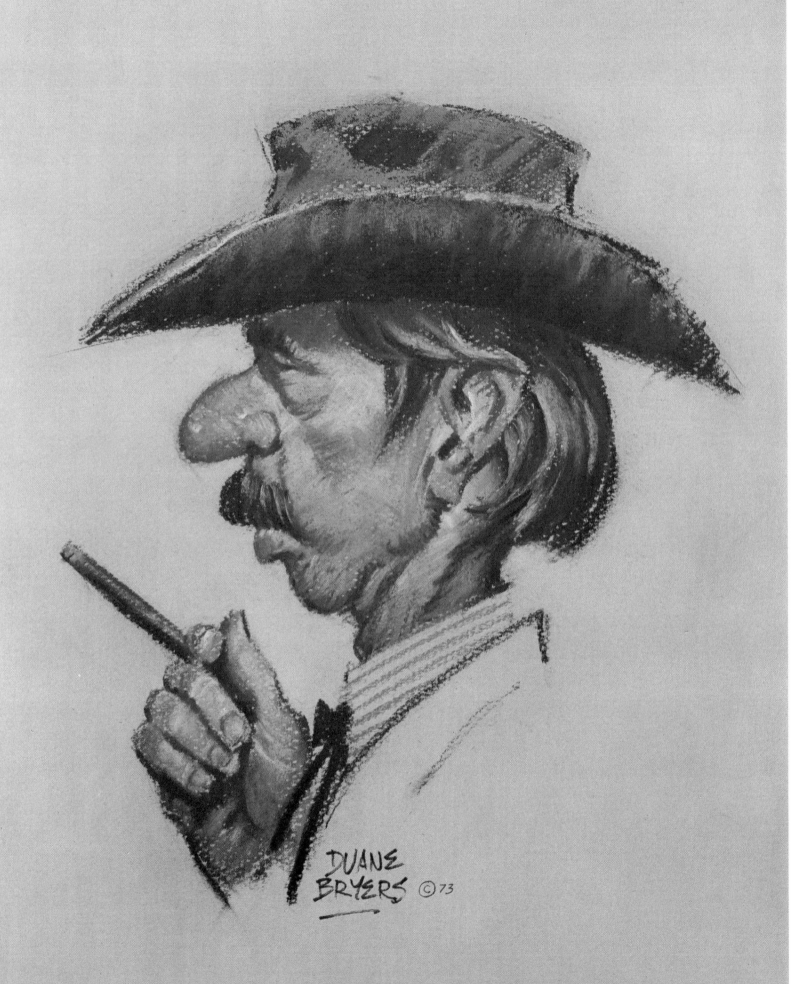

"Snoot" Fuller

Snoot couldn't tolerate being vertical any longer than his work required. And he wasn't likely to get corralled into doing any work what interfered with his shut-eye — especially after a hard night of elbow-bending. He and Hank Klackhorn tended line camp, Hank being the only one who could sleep through Snoot's snorin' which was about as soothin' as the sound of a bronc gettin' busted. Hank spent more time huntin' through the mesquite for Snoot than he did looking for strays. Only thing closer to Snoot's heart than his bedroll was Mudball, his old snorty horse. He had Mudball trained to start blowin' whenever anything on two legs came near.

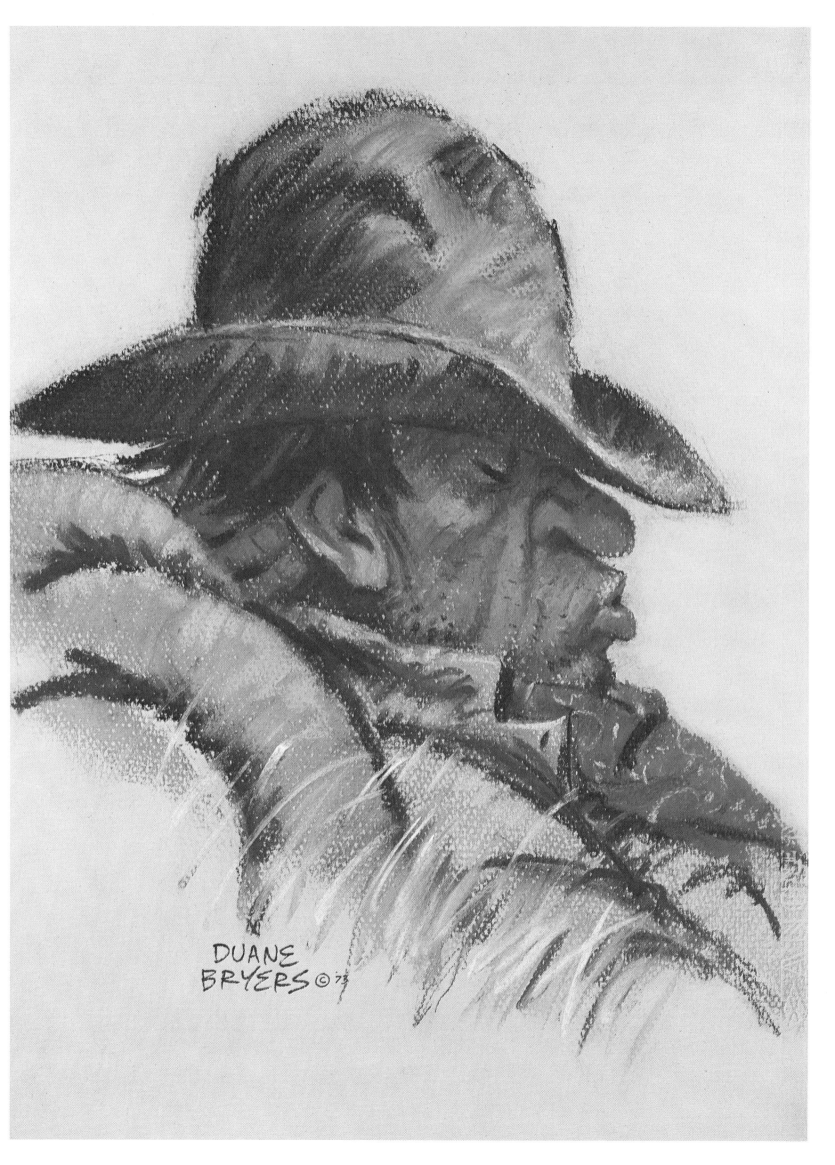

Hank Klackhorn

When he wasn't line camping, Hank was the Lazy Daisy's ramrod on roundups and beef drives. He never went no further than the fifth grade, but he sure was good at numbers. One squint at a herd of cattle and he knew to the cow how many head. Said it was easy, just count the legs and divide by four. Pops would get madder'n hell when he saw Hank counting the beans in his chili. Hank knew every gully, wash and creek for fifty miles in any direction and could find whatever needed locatin' — whether it was slick-eared calves, water holes, rustlers or Snoot Fuller.

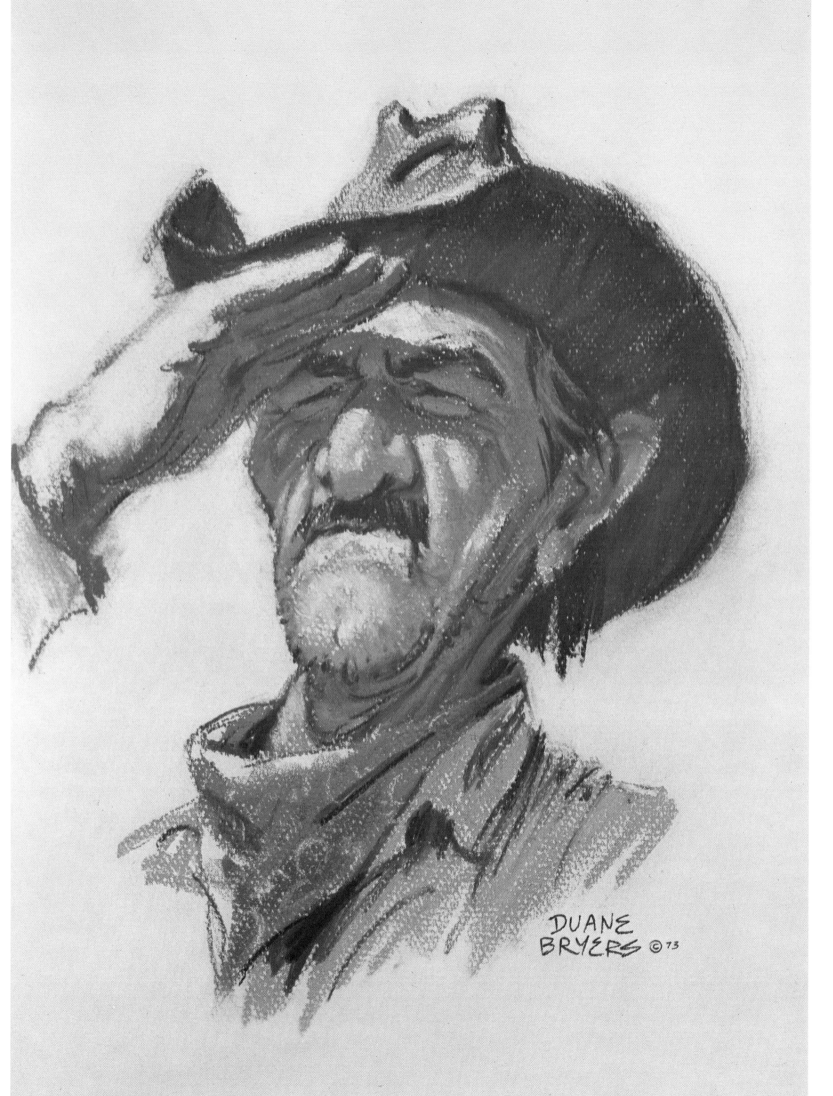

DUANE
BRYERS © 73

"Dirty" Poole

Every year Dirty would show up at the Lazy Daisy lookin' for a grubstake so's he and Sawdust could "strike 'er rich." He figured someday his gold dust had to assay less than 8o% alkali. The boys wouldn't let him stay in the bunkhouse, but Dirty didn't mind — said it wasn't healthy or natural. By the time Sawdust was puttin' on weight from eating grass 'stead of sagebrush, the boys were running a high fever and investing a month's pay in Dirty's new diggings. Dirty's parting words were always, "So long, pardners. I won't fergit yuh." And he didn't. Next year he was back again with new prospects and fresh hopes.

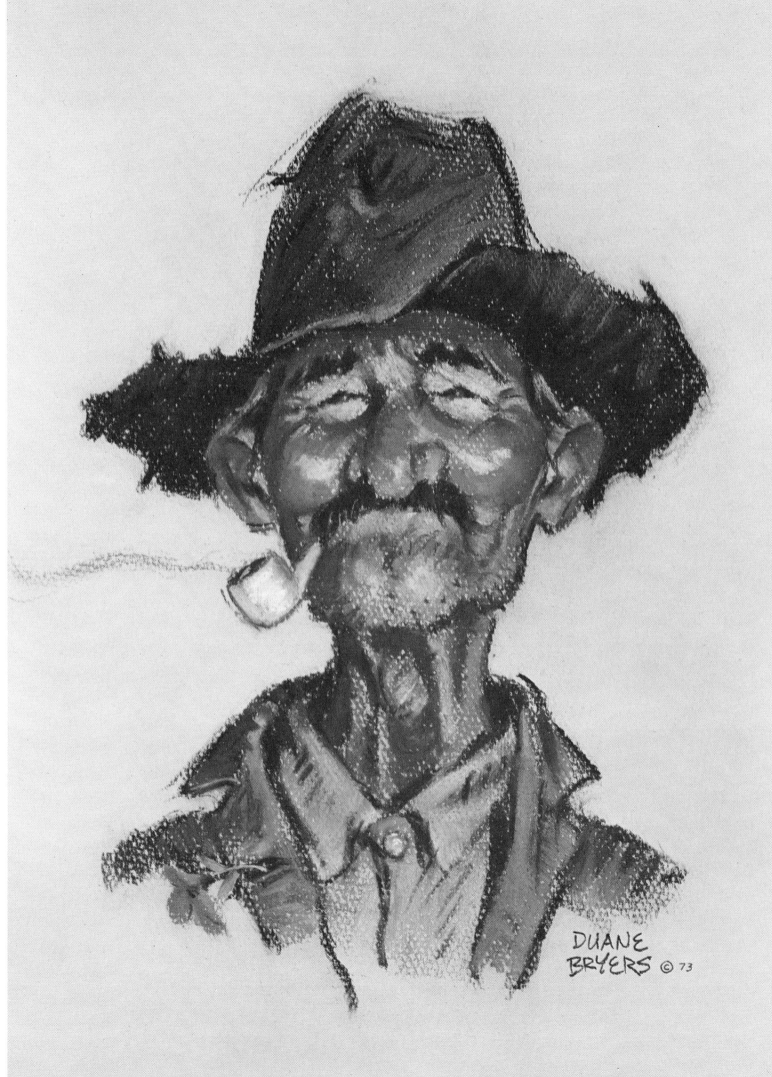

DUANE
BRYERS © 73

"Rusty" Hawkins

Rusty didn't stay long in one spot. That fiddle-footed ranahan had been on the move ever since he was fifteen and sold his old lady's cow for five bucks. Soon as he could finagle a scheme to boost his forty-a-month, he was ready to draw his time. A feller could get plumb dizzy eyeballin' Rusty twisting through the herd on a good cuttin' horse, spinning and turning quicker'n the cow could duck or dodge. Trouble was, he didn't do so good at cutting things out for himself. Like when he talked a greenhorn into buying his "claim" back in Arizona. The dude hit pay dirt, and from then on Rusty would break out in hives every time he saw something made out of copper.

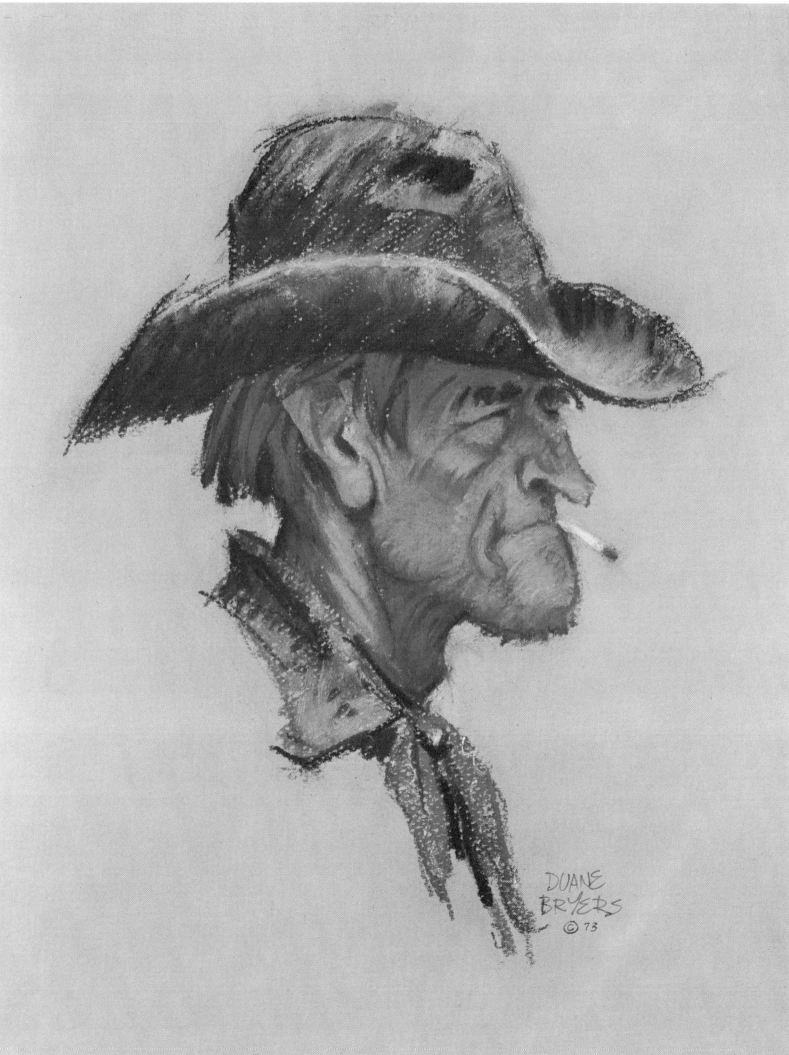

"Spitz" Fuerder

Spitz was Old Man Fuerder's youngun from the next ranch over.
The old man ran him off for tryin' to corner the hired gal down by the
barn. He was an ornery little cuss but a right good hay hand and
the only one the foreman's wife could get to do the milkin' — pro-
viding she kept the pitchfork between her and the milkin' stool.
Something Spitz liked even better than petticoats was his chewin'
tobacco. One day the boys doctored his plug with hot pepper sauce,
and he dang near swallered his neck up to his shoulders. 'Til then, he
never had learned to spit proper.

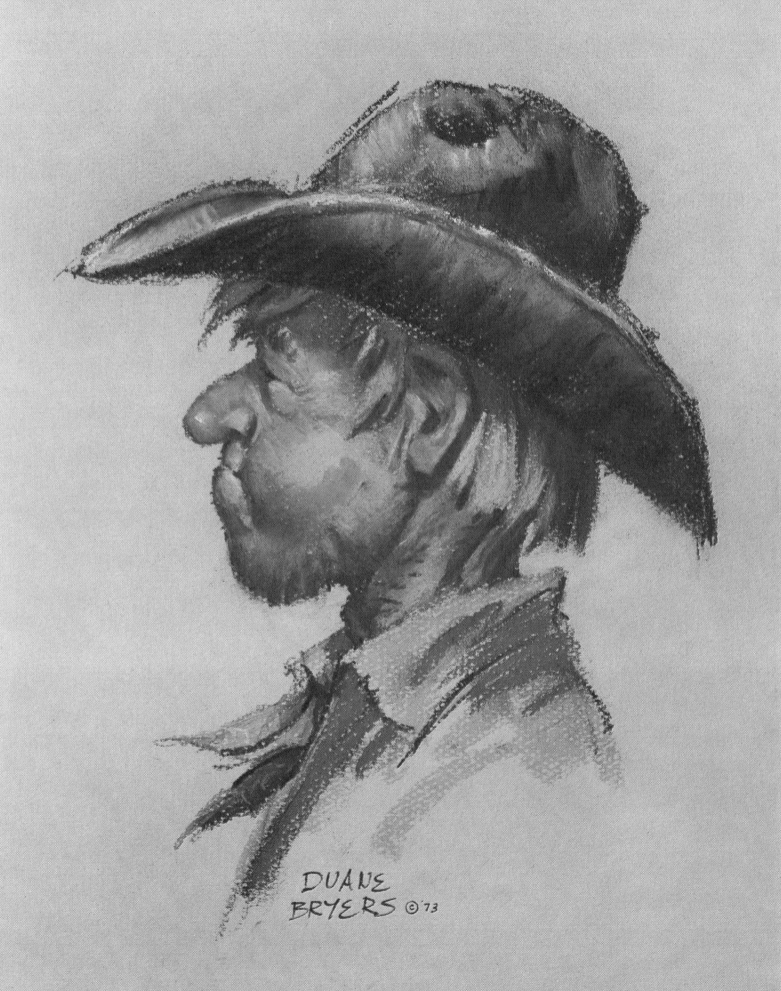

DUANE
BRYERS © '73

"Slim" Skinner

Slim was a good ol' boy. It's just that he was a mite jumpy about his past catching up with him. He never did no rustling or horse stealing — only piddlin' things like "forgetting" to pay for a couple of sacks of Durham or helping himself to a few extra toothpicks, say a pocketful. And he didn't feel none too easy regardin' the twenty bucks he owed Rusty on a saddle deal. Soon as Slim recollected that he didn't owe you nothing or hadn't "borried" something, he was right friendly — give you the shirt off his back if you needed it. But then it probably wasn't his in the first place.

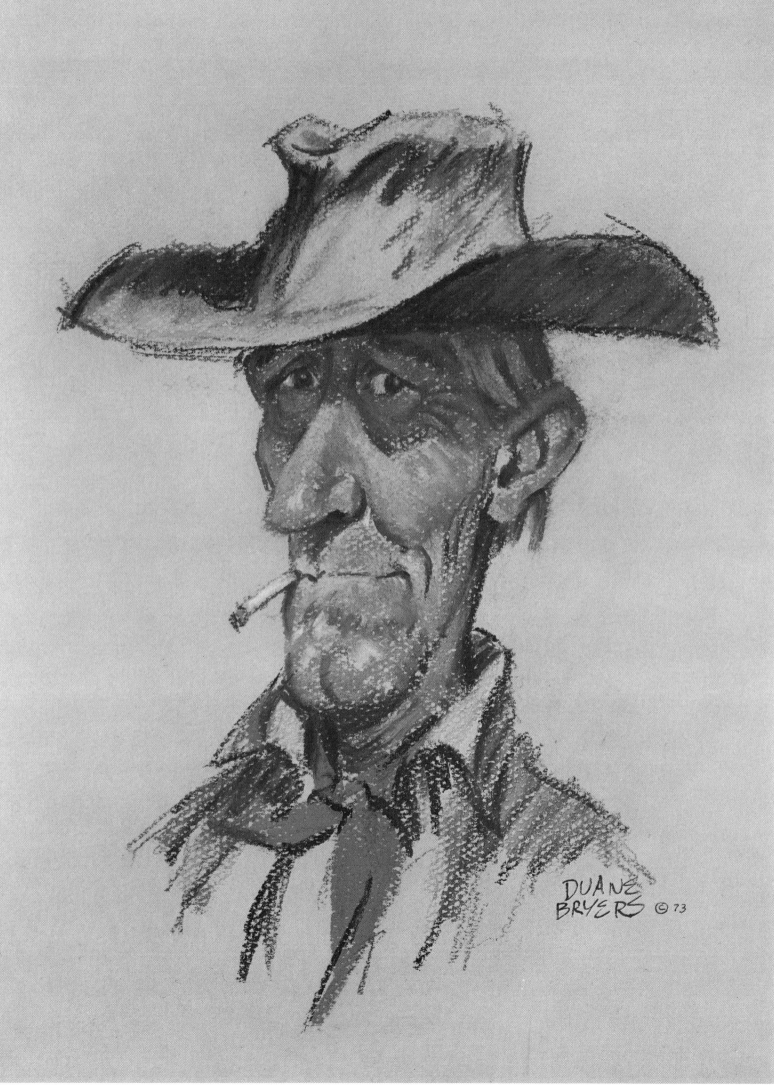

"Hap" Holleran

Life was one big knee-slappin' joke to Hap — course, he gave it a
little nudge now and then. He got fidgety if things were too dull. But it
didn't make no difference if the joke was on him or the next feller.
That's why he liked being nighthawk — gave him time to hatch new
pranks. He sang, too, if that coyote howl could be called singin'.
The boys could hear him off in the distance, ridin' night herd and
bellerin' "I never saw a straight banana" or "I wonder how I look
when I'm asleep." He said the cows fancied them songs better than
stuff like "Home in the Range" which "they was tard of hearin'."

54

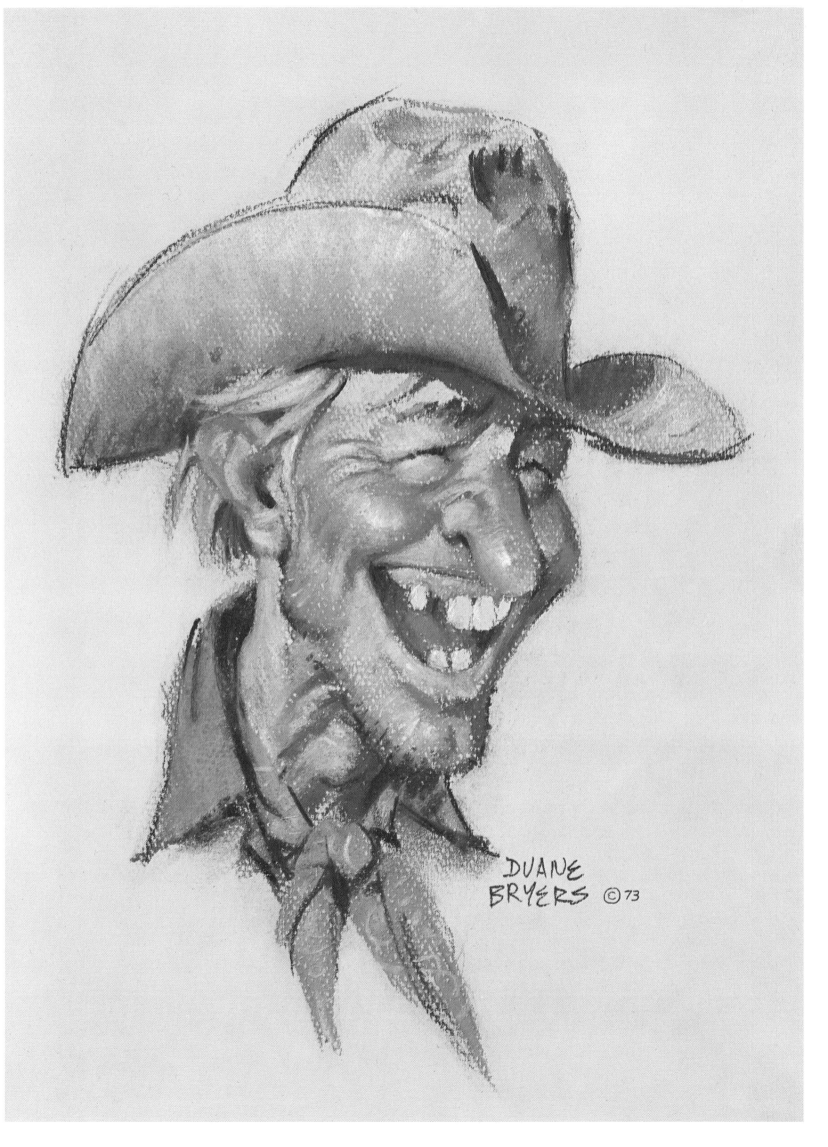

DUANE
BRYERS ©73

"Flub" Fickett

Bad luck didn't just dog Flub — it was waitin' for him 'round every
bend in the trail. He couldn't dig a posthole without hittin' bedrock,
couldn't brand a calf without grabbin' the hot end of the iron.
Every bell horse in the remuda knew when Flub was standing guard
and would scatter in every direction, and he'd be all night and half
the next day huntin' for 'em. Even his own horse was cantankerous —
he was in and out of his saddle like a yo-yo. The boys gave him a
rabbit's foot, and he said he'd wear it but didn't reckon it would
help — it hadn't done the rabbit no good.

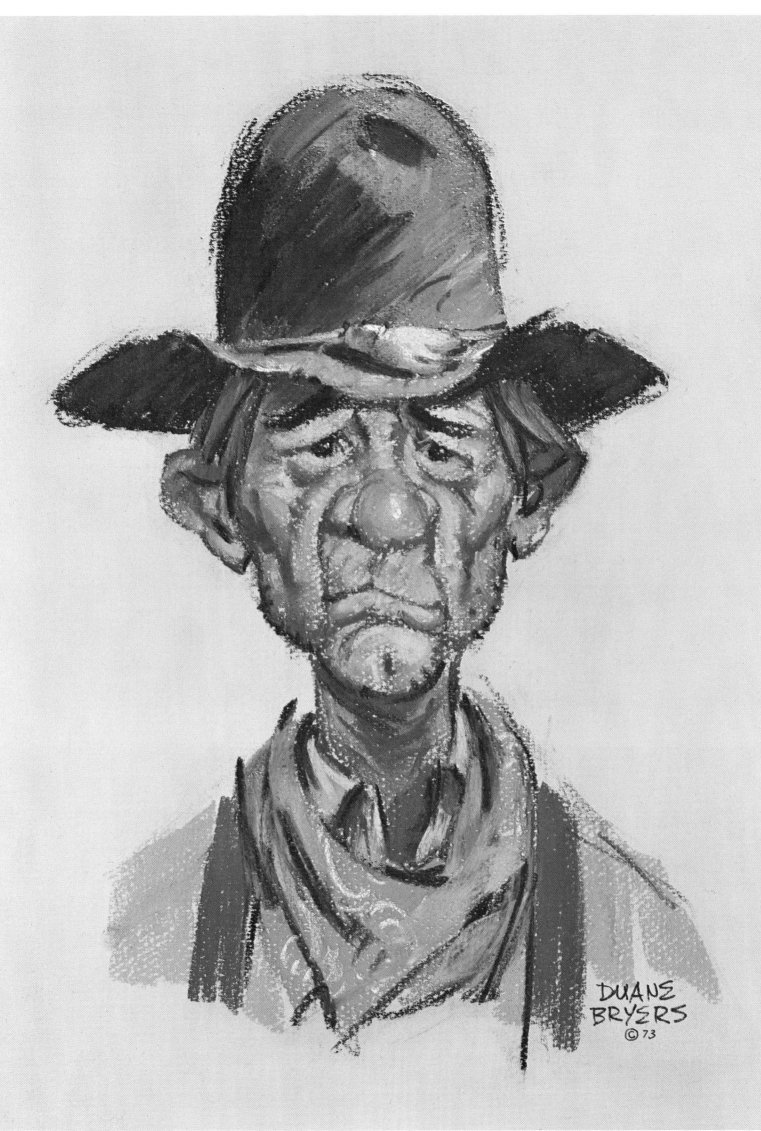

Eb Dingle

Ol' Eb used to be one of the best bronc riders west of the Missouri —
he was known as Ding Dang Dingle from Dumas. The boys would
holler, "Hang in there Dingle, don't dangle!" There wasn't a bone
in his body that hadn't been broke at one time or another — and some
of them twice. Those two front teeth were all he brought with him
when he started wrangling for the Lazy Daisy. Horses had swapped
ends under him so many times he didn't trust even sittin' on a chair
anymore. But he was still top hand at horse gentlin' when it came to
learnin' the boys how to saddle a cross-hobbled bronc.

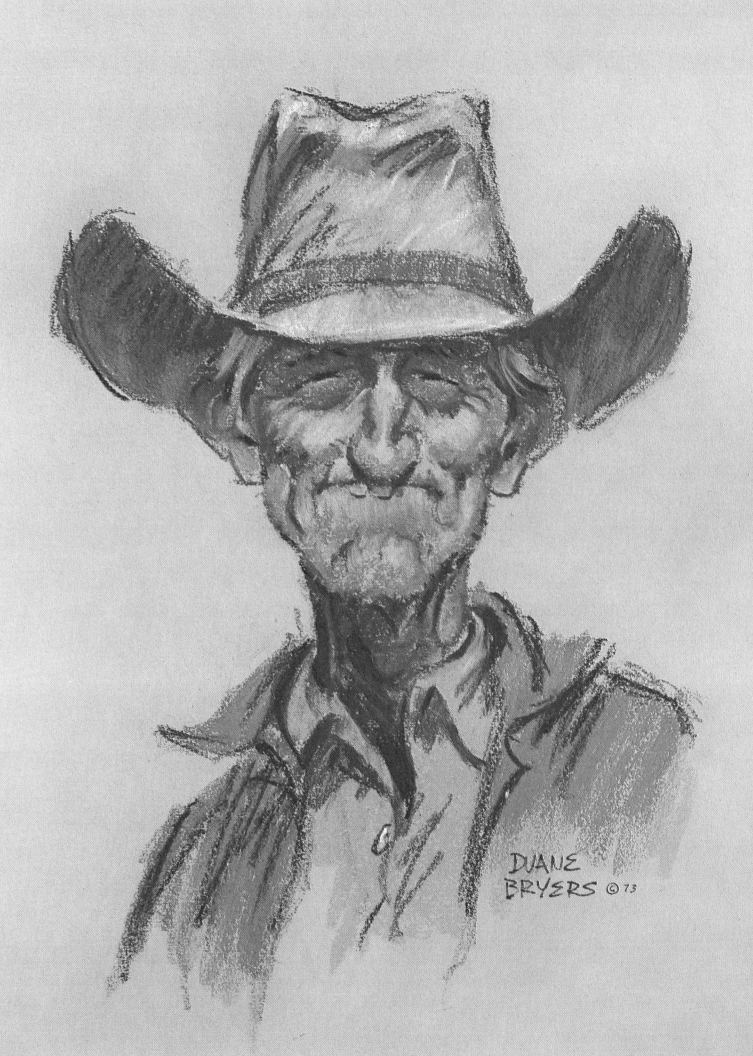

DUANE
BRYERS © 73

"Sourdough" Wilkins

The only critter Sourdough trusted was his boot-lickin' old hound.
When he and Shadow drifted in from herding sheep just before
fall roundup, the Lazy Daisy was hiring anybody who knew which end
the cow's head was on. The boys were a mite sensitive to the odor
of sheep, and Sourdough didn't take it kindly when they dunked him in
the dip tank. Gettin' wet was almost as agonizing as being froze,
according to Sourdough. He sure hated those three-dog nights on the
open range with only Shadow to share his bedroll. The boys tagged
him "Sourdough" because he had to be kept warm in freezin' weather.

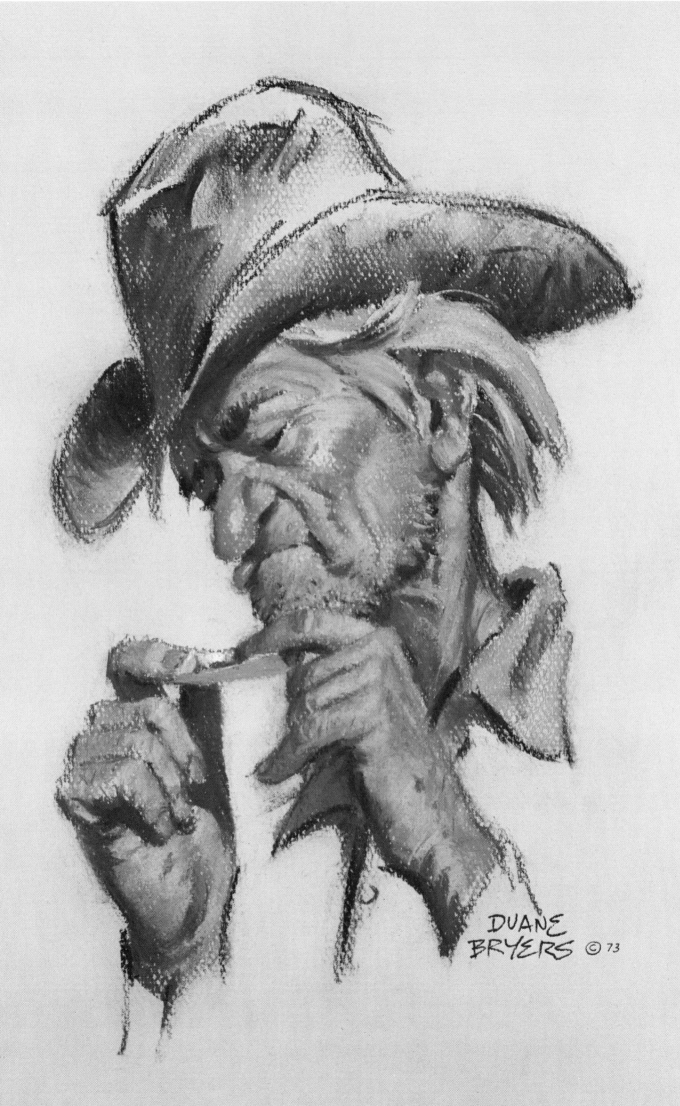

Ernest Pride III

Ernie — the boys had another name for him — was the ranch owner's nephew from back East where he was goin' to college. He knew all about cowboys and Indians. Kept telling the fellers they ought to shape up and be "real" cowboys like William S. Hart and Tom Mix and wear their neckerchiefs hindside backwards. He even showed 'em how to twirl their "six-pistols" after a fast draw and said it looked better if they'd shoot from the hip. When the boys couldn't stand no more they took to staying in town 'til the foreman told Ernie about a tribe of Indians over in the next county that maybe he'd enjoy visitin'.

62

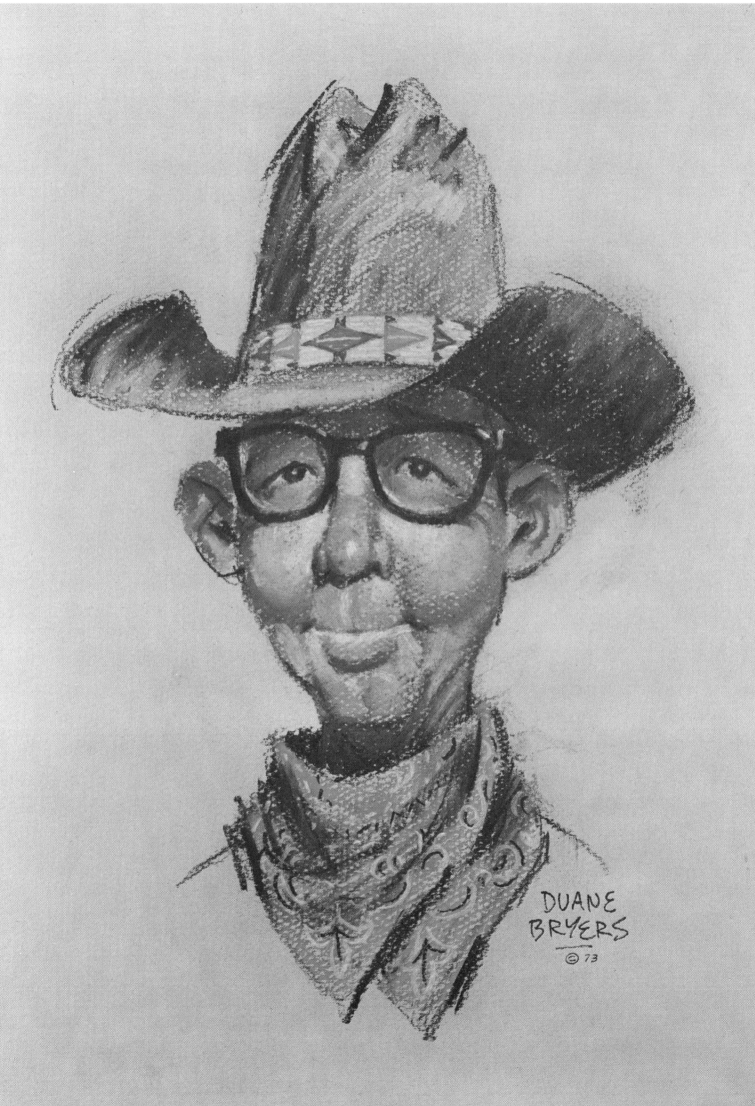

Dallas Fortwirt

His lanky, saddle-warped frame forked that old bald-faced sorrel like
he hadn't ever been off it. The idea of walkin' was outright foreign to
Big D. If his feet weren't in stirrups, he figured he was in bigger
trouble than a bogged-down cow. Top roper for the Lazy Daisy, it was
pure pleasure watchin' him flip a hooley-ann loop to catch the boys'
horses. With forty-five feet of manila tied to his saddlehorn, that
long-backed Texan could rope a locomotive goin' sixty miles an
hour and tie it to the caboose. Only two things Dallas was scared
of — bein' set afoot and women.

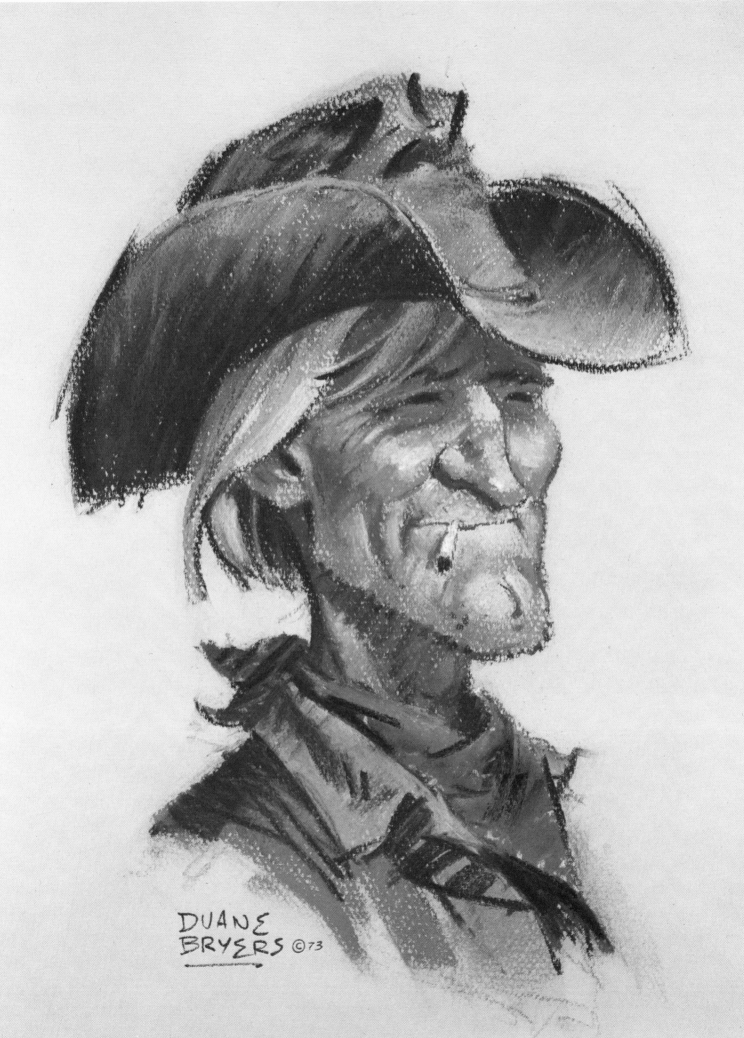

Alfie Cootz

Alfie helped out around the livery stable in town 'til one day he follered Big D back to the ranch and nobody could figure how to get shut of him. They didn't try very hard. Alfie was a maverick and 'bout busted his britches being useful. The foreman's missus fixed up a spare room and was always saving a hunk of pie for him. He shied at going to school — said a feller didn't need to know no 'rithmetic to draw a cow. Every inch of wall and wagon side was covered with Alfie's chalk scratchin'. When he grew up and left the ranch, he promised to come back someday and paint the boys' pictures.

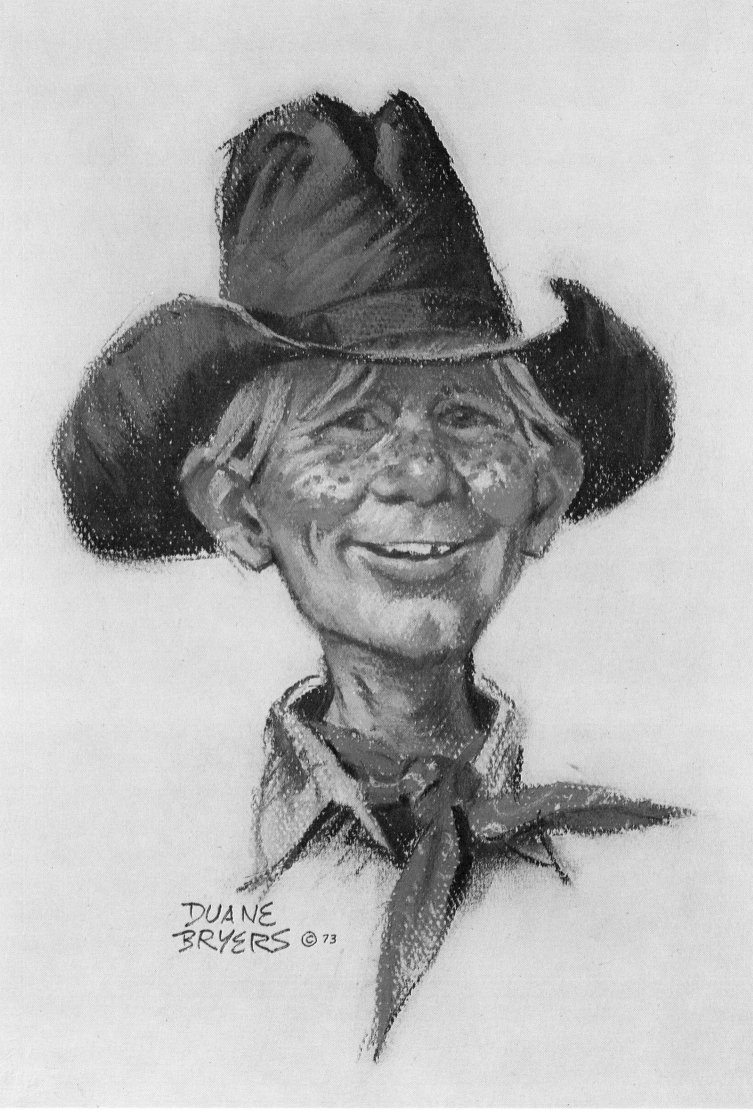

DUANE
BRYERS © 73

Willie Snively

It's a wonder every cow on this ranch wasn't hell and gone into the next county. Sending Willie out to mend fence was same as givin' him a round trip ticket to heaven. Six weeks later he was riding back with three feet of bob wire and a passel of younguns — jackrabbits, prairie dogs, horny toads, and once a "kitty." That's what Willie called it. What the boys called it was unprintable. Getting Willie to disagree just wasn't possible. Hap once said to him, "Shore looks like rain." Wasn't a cloud in the sky, and Willie says, "Danged if it don't." Half the varmints in the bunkhouse were Willie's pets, but the fellers didn't mind — long as they didn't have to ride fence.

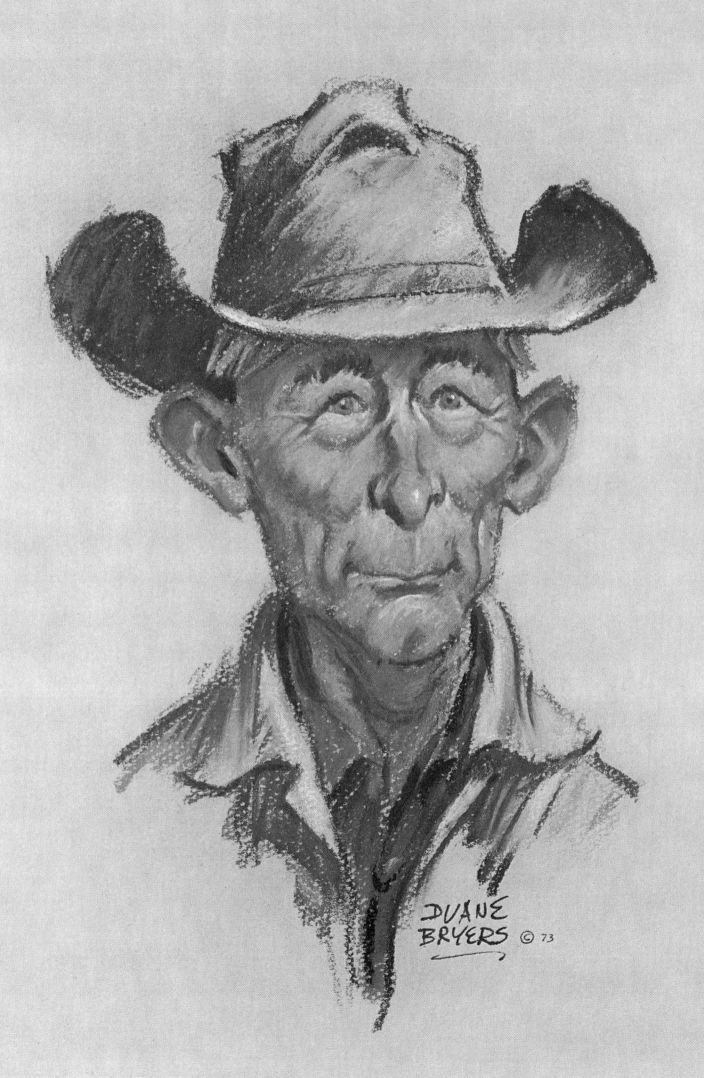

Oats Weevil

That was his real name — Oats. He was raised in Oklahoma and never did know there was anything to eat except corn bread and clabber milk. He sure wasn't no payin' proposition to have around. Things just naturally disintegrated once he got close to 'em, including a wife back in Durant. Even Churnhead, his slab-sided old mare, got the shakes when she saw him comin' with that hunk of chewed-up hide he called a saddle. His pockets were full of wire and string and rusty nails to fix things with — if he ever got around to it. Oats had a knack for shoeing horses, though — horseshoes being more or less indestructible.

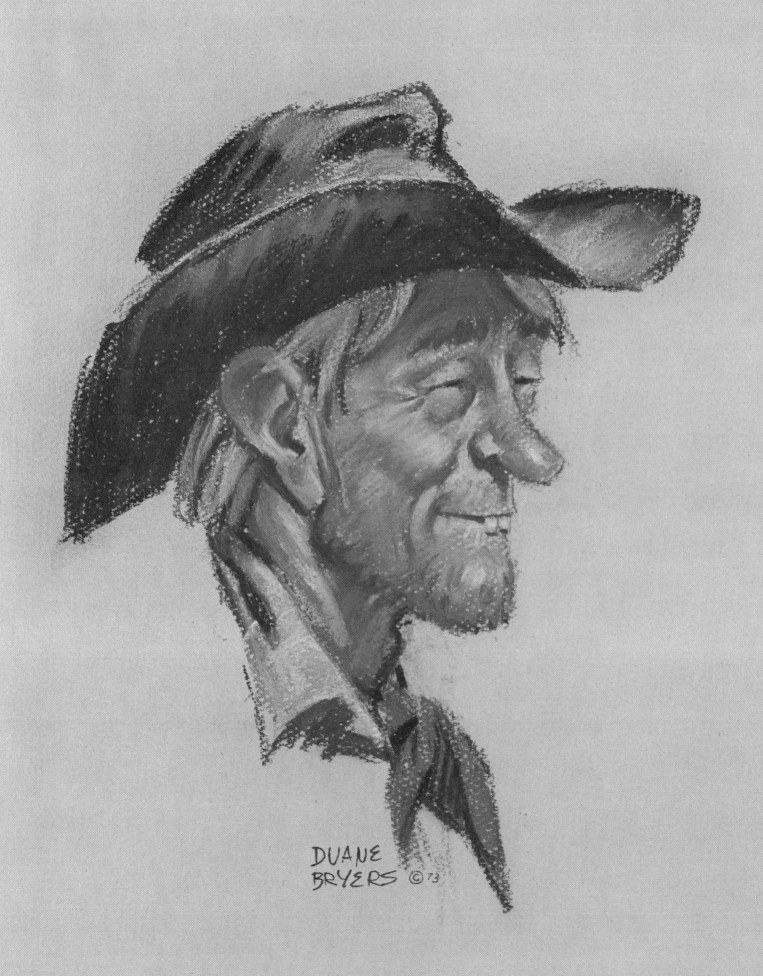

"Mule" Scruggs

Easy going but stubborn as his nickname once he got a notion. When
he was no higher than a stirrup, he was of a mind to be a cowboy.
It was Mule first, last, and any ol' time at storytelling. He'd look
a feller square in the eye, both ears twitchin', and spin some long-
winded yarn like it was gospel truth — and never tell the same story
twice. With the cows on bed-ground and the boys resting 'round
the fire, Mule was plumb inspired. The fuller the moon, the taller his
tales. 'Til somebody would ask, "Mule, if that's true how come you're
still alive?" and Mule would say, "I ain't." But his ears would twitch
faster than ever.

72

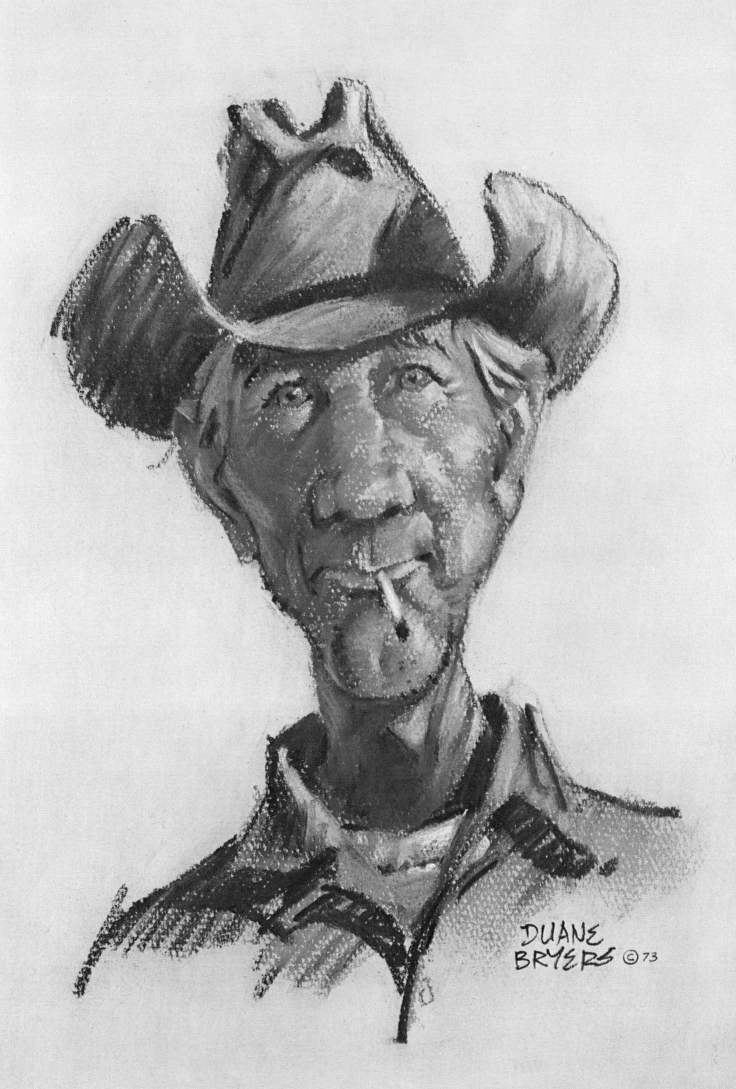

"Judge" Rapp

He was a friend of the boys. In fact, he was a friend of everybody.
You just about had to stay on good terms with the "Judge." He owned
the hotel, the livery stable, the saloon, and it was suspicioned one
other friendly establishment, but he was careful not to mention it. The
handle "Judge" was more or less acquired by self-appointment,
but nobody saw fit to disagree with his choice. And I reckon he was
fair as any when it came to making decisions. The only time there
was some doubt was when he fined Old Andy $2.00 for obstructing
traffic. A runaway horse belonging to the banker had sent Andy
sprawling into the middle of the street.

74

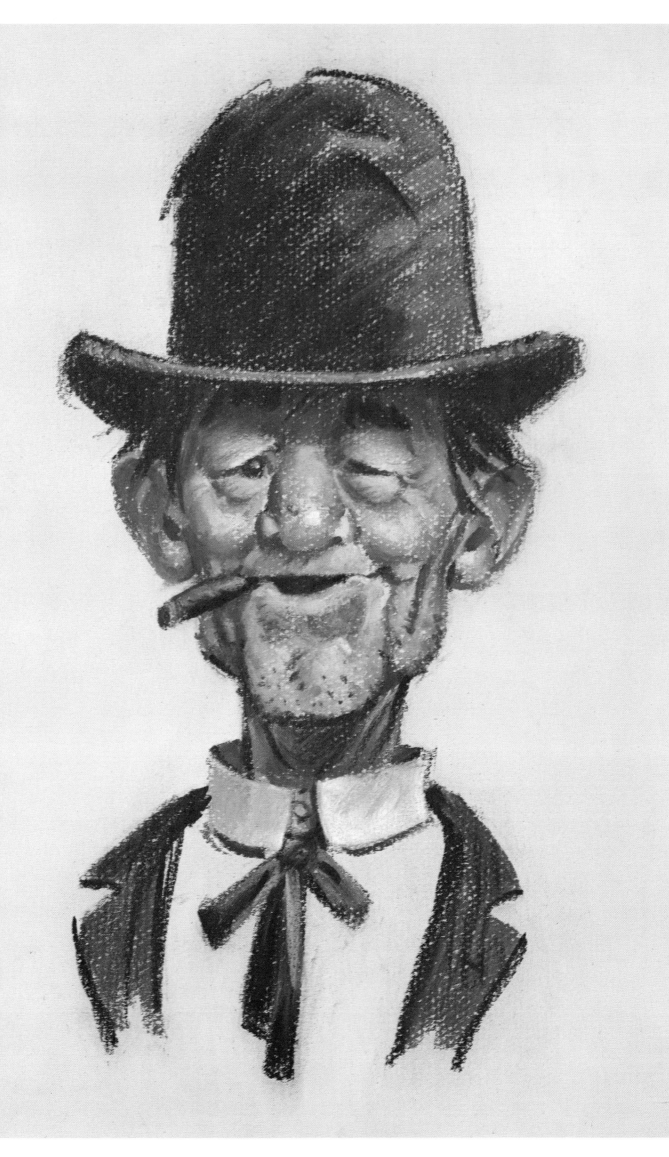

Jake Moss

Now I'll tell one on me. No better and no worse than these other roosters. Luckier than some. I'll admit straightaway that marrying Nell was the only time I ever took the best of it. I've rode the rough string and done my share of wrangling for the Lazy Daisy since I had fuzz for whiskers and old timers were telling me the West was plowed under. Sure there's fences now and smaller herds but a man can still live accordin' to his druthers and take care of what's his. As long as I've got my makings and can get a leg over a horse, I figure I've come out a little to the good.

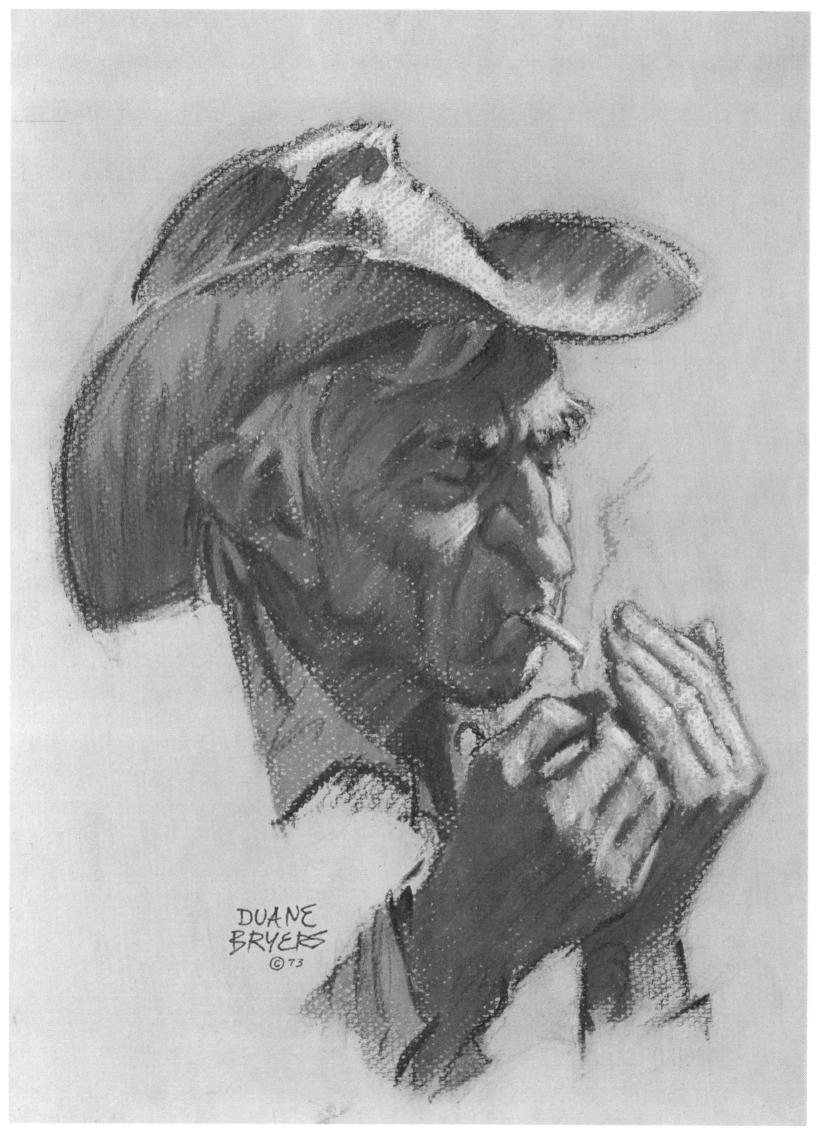

DUANE
BRYERS
© 73

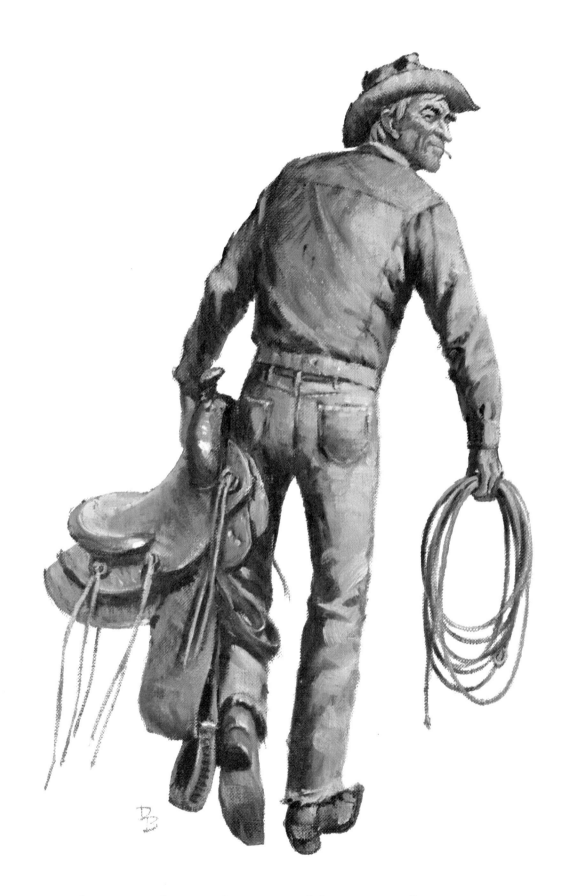

WELL, I RECKON that's most of 'em — they come and they go. You all drop in again sometime — I got to see how my new wrangler's doin'.

79

This book
was designed by Robert Jacobson
and set in 12-point Aldus
with Palatino titling.
It was printed on Vicksburg Vellum
at Northland Press
and bound at Roswell Bindery.